CHRISTMAS
IN *Detroit*

Todd,

Merry Christmas
Brother.

Love you

Cindy

2020

CHRISTMAS
IN *Detroit*

BILL LOOMIS

THE
History
PRESS

Published by The History Press
Charleston, SC
www.historypress.com

Front cover: Shopping; Crowds; Christmas Shoppers Downtown, 1936-12-19. Detroit News Photographs #72681. *Walter P. Reuther Library, Archives of Labor and Urban Affairs, Wayne State University.*

First published 2022

Manufactured in the United States

ISBN 9781467150927

Library of Congress Control Number: 2022943525

CONTENTS

This book is lovingly dedicated to my grandchildren, Cal and Nika, who at a young age have already seen more places in the world than most people see in a lifetime.

ACKNOWLEDGEMENTS

Ralph Naveaux is among the most knowledgeable historians of Detroit during the years it was a French colony. He is also a recognized historian of the Battle of the River Raisin and the War of 1812. His most recently published book is titled *Invaded on All Sides*. For fifteen years, he was employed as a teacher of history and French in the Monroe Public School System. Mr. Naveaux retired as director of the Monroe County Historical Museum in January 2007. He generously reviewed the chapter on Christmas during the days of French Detroit.

Ann Delisi has been with WDET in Detroit since 1983 and is a well-known advocate, historian, journalist and commentator on contemporary music and Detroit music in particular. I'm grateful for her review of the chapter on Aretha Franklin's Christmas celebrations and music.

Terry Gallagher's family has lived in Detroit for several generations. His father, Thomas Gallagher, was a well-known administrative law judge for the Social Security Administration and was a prominent figure among the Good Fellows at Christmas time. Terry kept up the Gallagher tradition with the Goodfellows and provided anecdotes and incites on working for that charity.

INTRODUCTION

I thought when considering doing a book on Christmas in Detroit that I might burn out reading articles and books on Christmas, which can be so maudlin and superficial. The idea of listening to Christmas music for a couple of years filled me with dread; I think I hit the bottom with Ren and Stimpy's album *Crock O' Christmas* or worse, country music star Alan Jackson's song, "Please Daddy, Don't Get Drunk on Christmas." Not my thing. And to be fair, some people love the Ren and Stimpy album from 1993 that they listened to as children.

But what happened as I researched Christmas was that I discovered how kind people in Detroit and southeastern Michigan were and are today and how many good people there have been over the years—something we haven't really seen in the last few years. Yes, Christmas can be too commercial, too loud and goofy with Ugly Sweater contests, sexy Santa outfits, decorated houses that would be more appropriate in Las Vegas. But it's just people having fun and feeling happy. It's also a tradition that we eagerly share with our children and friends: the cooking, the parties, the trips to Hudson's, church and Christmas music performances, Christmas trees and, of course, Santa and Christmas presents—in short, a tradition of happiness.

There was a pattern I saw in reading articles from Detroit newspapers, letters and books, some going back 160 years. The pattern usually began when something happened to someone during the Christmas season when they were a child—something that was in some cases good and made them feel special and happy or, more frequently, something said or done that hurt

them deeply, wounded for life, many times to be shutout, humiliated or, most commonly, to be forgotten and have nothing, even to eat, on Christmas morning. They probably had many mornings with nothing, but somehow on Christmas, it affected them so profoundly that some made it a lifelong commitment to be sure no child ever goes without something on Christmas. It wasn't a tragic event, like the little girl who goes to see Santa at Hudson's and tells him she doesn't want any presents, she wants her mommy, who died that year, back. (That happened.) Rather, it was something that could have been prevented if someone had cared.

Christmas in Detroit belongs to people who want to be good and care and enjoy making others happy—to be generous. Generosity is not giving something to someone because it's owed or deserved; it's giving something to someone that is yours. French philosopher André Comte-Sponville wrote: "The virtue of generosity combines with other things and it takes on a different name. For instance, generosity combined with courage can become heroism. Combined with mercy it becomes leniency. But its most beautiful name is an open secret that everyone knows: combined with gentleness generosity becomes kindness."

Fred Huseman was a retired security guard at Macomb Community College. In the 1970s, Huseman played Santa Claus for nearly ten years at Hudson's downtown and became the head of the Hudson Santas (there were ten of them). He said, "Playing Santa is a privilege. I believe in it."

That was the fun of writing this book, meeting people at their most beautiful.

Chapter 1

THE START OF THE AMERICAN CHRISTMAS

Christmas is a holiday not based on the Bible; for years, Protestants refused to recognize Christmas because it was not the date of the birth of Jesus but was begun to convert Roman citizens from a pagan celebration to a Christian one. They insisted it was not acknowledged in Biblical scripture. They also noted the references to the shepherds, who came to visit the manger and the baby Jesus and who watched their flocks at night. Those against Christmas claimed the month of December was too rainy and cold in the Middle East to sit outside all night watching anything.

Of course, Christmas didn't begin this way. In jolly old England, it more resembled the Roman holiday Saturnalia than what the early Christians in Rome were offering: drunkenness, lewd behavior, social role reversal (in which servants were served good food and expensive wines by their masters and men and women switched clothing) and wassailing by roving bands of tipsy louts who simply walked into a person's home and demanded food and drink. The New England Puritans railed against Christmas. They rejected the holiday, declaring the behavior appalling, made even more horrific as it was sanctioned on the presumed birthday of Jesus Christ.

In New England, Minister Cotton Mather declared that "Abominable Things" were occurring, likely referring to sexual acts. There was some confirming evidence of this in the demographics. Social historians found that there was a steep rise in premarital pregnancy throughout New England in the seventeenth century. In some New England towns of the times, over

half the children were born in the months of September and October, which meant sexual activity was at its peak during the Christmas season, as reported by Stephen Nissenbaum in his book *The Battle for Christmas*.

Eventually, the Puritans and other conservatives began to warm to the idea of Christmas as long as it didn't include the obnoxious behavior of the "lower orders" or working class. So, people knew what they didn't want to be Christmas, but what it could become before Santa Claus was vague and usually serious: it meant attending church and what one leader called "solemnity and devotional feelings." You can just picture how excited the children were anticipating that version of Christmas.

PROTESTANT CHRISTMAS IN DETROIT

In Maine and some other portions of New England, there was no observance whatever of Christmas and but partially so of New Years. On December 25, 1857, the *Detroit Free Press* reported, "Children grow to maturity without knowing the 25th of December and 1st of January are gala days among most of the Christian nations on earth."

In the first half of the nineteenth century, Christmas was celebrated in the southern United States, where Catholics were among the first European settlers in the regions, but not recognized in New England states. The first Christmas tree in the White House was not put up until 1856, by President Franklin Pierce.

Since most of the early Protestants who came to Detroit were from western New York and Massachusetts, Detroit Protestants saw Christmas as a social event, not a religious one. None of the Protestant denominations paid any attention to it, and they had no services at Christmas, but stores and shops closed at noon. In general, people saw it as a holiday and had dinners and exchanged gifts. A popular Christmas Day activity for men was horseback racing, if the street conditions were good. According to social historian Friend Palmer, they raced their French ponies and horses on Jefferson Avenue from Dequindre Street to downtown and up and down Michigan Avenue. When the street conditions were poor, they would race on the ice of the Detroit River, assuming it was solid enough. (In those days, horses were equipped with special sharp shoes that dug into the ice and snow as they moved.) In 1851, Ulysses S. Grant was a lieutenant in the army, stationed in Detroit after the Mexican War. He was frequently seen racing horses during the holiday on the streets or the river.

It was the custom on the night before Christmas to usher in the day with the blowing of horns and firing of guns, which began at midnight and was kept up until daylight. Friend Palmer wrote that this custom was most prevalent among the German portion of the city. Large banquets were enjoyed by all at Dan Whipple's tavern, which was a tradition through the 1840s. It was seen as a day to be social and charitable, a time of feasting, partying and visiting friends.

It is claimed that Protestant American Christmas traditions were begun in the nineteenth century by three men: the New York writer Washington Irving; Clement Clarke Moore, the author of "A Visit from St. Nicolas," aka "the Night Before Christmas"; and Charles Dickens, who wrote the novella *A Christmas Carol*.

In the 1820s, Washington Irving published a book of stories called *Sketchbook of Geoffrey Crayon, Gent*, which included classics "Rip Van Winkle" and "The Legend of Sleepy Hollow" and made Irving an internationally famous name. *Sketchbook* also has five essays about Christmas that take place not in Dutch New York but in England at an estate called Bracebridge Hall, all fictitious. What Irving does is has his kindly squire convince the locals to reenact old Christmas traditions, which they do, but those "traditions" never occurred—all of them were made up by Irving. Squire Bracebridge contemplates the occasion "seemed to throw open every door, and unlock every heart. It brought peasant and the peer together, and blended all ranks in one warm generous flow of joy and kindness."

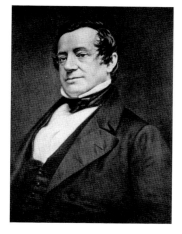

But Bracebridge's social experiment actually fails. The area peasants no longer know how to play their parts, and "many uncouth circumstances occurred." He muses on why: "The Nation [England] has altered; we have lost our simple, true hearted peasantry." People of different classes needed to mingle again to see that they all share in life.

While Irving wrote about an English Christmas, what came across and became popular in people's hearts was a holiday of warm feelings, traditions, love, kindness, feasting, reverential worship and children's laughter.

Clement Clarke Moore was the author of "'Twas the night before Christmas," or, as he titled it, "A Visit from Saint Nicholas." He

Washington Irving. Copy daguerreotype by Mathew Brady, reverse of original by John Plumbe. *Library of Congress.*

wrote the poem in 1822 for his two daughters. Moore's family owned huge tracts of land on Manhattan that was farmland in 1822. It was basically the neighborhood of what is now Chelsea, north of Greenwich Village. He was wealthy and a serious scholar of ancient languages. His poem completely changed the notion of Santa Claus.

Prior to Moore's poem, St. Nicholas was portrayed in the New York newspapers in 1810 as he likely was in life: a saint with a halo, the patron saint of both Russia and Greece, wearing his bishop robes and carrying a scepter. He was a figure of authority and benevolence who was kind but hardly jolly. A bishop is a spokesman of God. As a bishop, he meted out rewards to good children and punishment for the naughty. He is also illustrated carrying a black rod, which God instructed was to be given to those parents whose children misbehave:

> But when I found the children naughty,
> In manners rude, in temper haughty,
> Thankless to parents, liars, swearers,
> Boxers, or cheats, or base tale-bearers,
> I left a long black rod,
> Such as the dread command of God,
> Directs a Parent's hand to use.
> When virtue's path his sons refuse.

> From The Children's Friend, *a children's book published in 1821.*
> *Moore's poem appeared only a year later.*

The historian Stephan Nissenbaum notes in his book *The Battle for Christmas* that this was like a child's version of the Christian Day of Judgement in which God judges people as good or evil and sends them to heaven or hell for eternity. In this lighter version, the reward (a cookie) or punishment (the rod), was at a level children could fully understand. This St. Nicholas visited homes on St. Nicholas Day, January 6. Nissenbaum points out that we still see glimpses of this notion in contemporary Christmas carols, like "Santa Claus Is Coming to Town":

> He knows when you are sleeping,
> He knows when you're awake.
> He knows if you've been bad or good,
> So be good for goodness sake.

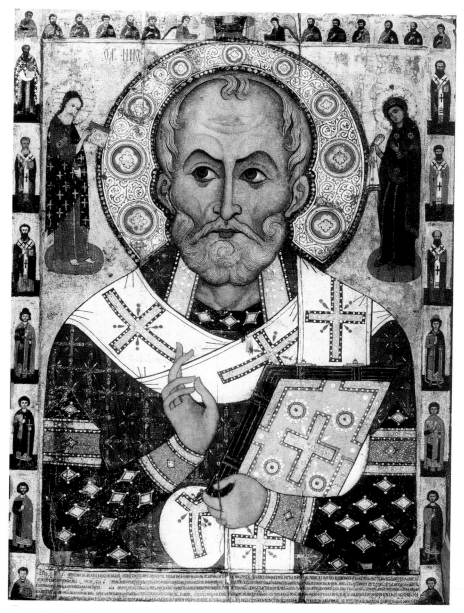

St. Nicholas "Lipensky" as he appears on a Russian icon dated to 1294 from Lipnya Church of St. Nicholas in Novgorod. *Wikipedia.*

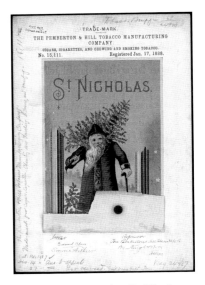

Advertisement showing St. Nicolas from 1888. *Wikipedia*.

Moore was among the first authors to have St. Nicholas arrive on Christmas Day, December 25. He removed the authority and judgmental purpose from St. Nicholas; it was now "Happy Christmas to all." He also removed the bishop robes and made him a figure of fun, so much so that the narrator, the father of the poem, bursts on laughing at the sight of Santa "in spite of myself." Moore claimed to have found his inspiration for St. Nicholas in "a portly, rubicund Dutchman" living near his family's estate in Chelsea. He's fat but small, "a jolly old elf" with tiny reindeer. (Santa Claus would get even bigger and fatter during the Victorian era with the illustrations of Thomas Nash.) Moore described him as dressed all in fur. His eyes twinkle, cheeks rosy. Moore said, "He looked like a pedlar—a pedlar just opening his pack." He smoked a short stumpy clay pipe—popular with tradesmen and laborers. Moore's Santa is a working-class elf. And just before he rises back up the chimney, he turns and looks directly at the narrator father with a smile, then touches the side of his nose, conveying the message: "We both know I don't really exist, but let's keep it to ourselves."

Charles Dickens wrote *A Christmas Carol* in the 1840s. He claimed one of the influences of his Christmas writing was Washington Irving. The Christmas Carol is known worldwide as the conversion of the miser Scrooge by terrifying visitations of ghosts.

Stephen Nissenbaum notes that it is also a Christmas lesson on the proper way to express kindness and generosity. In the 1800s, English society was forming into distinct classes of people, mostly unknown to one another—vast, nameless masses living and working in poverty and extremely wealthy and entitled industrialists. Scrooge is a merchant and employs Bob Cratchit as his clerk. At the start of the story, Scrooge—before his conversion—rejects the request of two men soliciting for a charity to help the poor. He also rejects his nephew's invitation to attend a family Christmas party. After his conversion, he bumps into the two men who had asked for a donation and whispers to them a generous sum. He also accepts

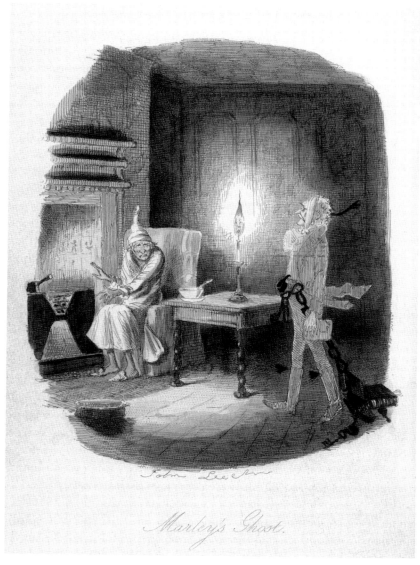

Marley's Ghost, original illustration by John Leech from the 1843 edition. *Wikipedia.*

his nephew's invitation and shows up smiling at the party. Nissenbaum says Dickens conveys it's best to address the poor through charities that know what they're about. Scrooge does not give gifts to his family but shows his love and kindness by being with them to celebrate in a cheerful way.

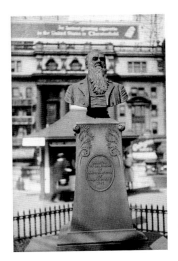

Statue of John J. Bagley, owner of J.J. Bagley Chewing Tobacco and later sixteenth governor of Michigan. The statue was in Campus Martius until 1926, when it was removed due to auto traffic. It was stored in the Arts Museum then transferred to the Detroit Institute of Arts, where it was kept in storage and forgotten until rediscovered by Detroit history writer Dan Austin. *Library of Congress.*

Finally, Scrooge must take care of Cratchit and his family, especially Tiny Tim, crippled by poverty. He buys them a gigantic turkey for Christmas and, importantly, has it delivered. He does not deliver the turkey himself, nor does he have dinner with them. Like Squire Bracebridge in Washington Irving's stories, Scrooge shows that one must attend to and show kindness to people who you know, who loyally work for you, but you do not befriend them by dining with them in their homes. To Dickens, this was important in Victorian England, whose population was splitting into distinct groups of haves and have nots.

In nineteenth-century Detroit, manufacturers closed up production and threw parties for their employees. Christmas had evolved to become a chance for people in all stations in life to show kindness, have fun and enjoy life. One of the most renowned business owners was John J. Bagley, who became governor of Michigan. The J.J. Bagley Company was one of many chewing tobacco manufacturers in Detroit. Bagley Street in Detroit is named after him. While in business in Detroit, the Bagley family was well known for fun and lavish Christmas parties:

Shouts of mirth and scenes of gayety prevailed in the factory of John J. Bagley and Company yesterday. From morning to night, the employees and their friends were guests of the company, and a royal good time they had. Altogether about 700 enjoyed the hospitalities offered. One big room was handsomely decorated with holly and bunting….The company has for many years made it a practice to celebrate Christmas in this manner, and one had only to look at the happy assemblage yesterday to be assured this kindness of the company was greatly appreciated. Detroit Free Press, *December 27, 1898*

EARLY BALLS

Detroiters began holding parties in their homes. In the 1830s, the population of Detroit was 2,222, about the same as it had been in 1805. The houses of Detroiters in those days were almost entirely built of wood, but the Abbott family's house on Jefferson near Griswold was stone and was the largest house in the city. The ball was a chance to show off their new home. People came from everywhere, including many from Windsor, then called Sandwich.

Mrs. Abbott, who was a well-known cook, cooked and supervised the preparation of the food. Unlike the later Victorian times, there were no decorations or flowers on the table, but it was loaded down with "venison, baked and garnished hams, cold tongue, calf's feet, jelly and cakes, heavy with fruit and adorned with pyramids of spun sugar and macaroons, jellies [gelatins] colored a scarlet hue and cups of custards and most of all plenty to drink, typically wine or brandy." While whiskey was available, it was considered too crude, appropriate for the lower levels of society. And of course, there was a huge bowl of eggnog and another of apple toddy, which was a mixture of apples and hot rum. The house was lit with the best-quality sperm whale candles, and starting at 7:00 p.m., guests began arriving—eventually totaling more than two hundred. This was before there was pavement of any kind on street or sidewalk, and the preferred mode of conveyance was the Norman pony cart, which rode high and could back up directly to a doorstep. Therefore, passengers could avoid having to step in the mud. Unfortunately, the carts could also be tippy, and one poor guest got dumped out of the cart into the slushy mud of the street. She had to go home and make repairs to her dress.

In 1835, Detroiters had not been introduced to the waltz, mazurka or even the polka. They danced the cotillion, later known as the quadrille, both early versions of a square dance. A fancy move in the cotillion was called the "pigeon wing," a move skilled men used to show off their stuff. There were lots of circling and stars being formed as couples went under arcs of clasped hands. The dancing went on all night, and the Abbott Ball was talked about for years.

EMILY MASON,
"CHRISTMAS IN DETROIT A HUNDRED YEARS AGO"

Emily Mason was a woman who lived her early life in Detroit. She was the third-oldest child in a family highly respected in nineteenth-century Detroit.

She was the younger sister of Stevens T. Mason, Michigan's "Boy Governor." President James Monroe appointed Emily's father, John Thomas Mason, as a U.S. marshal. Mason was appointed secretary of Michigan Territory and superintendent of Indian affairs in 1830 by President Andrew Jackson, so he moved his family to Detroit. He held those appointments until 1831, when he was sent to Mexico on a mission by President Jackson. To fill the secretary of Michigan Territory post, President Jackson appointed Mason's son Stevens. Stevens later became the first governor of Michigan on October 6, 1835. Stevens Mason's remains are buried in Capitol Park in downtown Detroit thanks to Emily Mason, who spent her later life campaigning to have her brother's remains brought to Detroit from New York, where he had died.

The Masons lived on Congress Street between Shelby and Wayne. "Great entertainments were given at their house, and all the bon-ton of the city were invited. She was a writer and an overall popular and charming woman in the early 19th Century who lived into her nineties and died in 1909." She was described by a Colonel Winder as follows: "She was the most beautiful and accomplished woman of her time, and I can give you no idea of the beauty and elegance of her appearance when she was a bridesmaid at my wedding." Later in life, she lived in Paris and conducted a girls' school for fourteen years, supporting herself with her writing.

At age twenty-seven, Emily wrote a letter to her father, John T. Mason, dated January 2, 1842. At the time, he was in Washington, D.C. Her letter highlights a Christmas celebration in Detroit in 1841. Here are some excerpts:

Detroit, Jany, 2d 1842
My dear Father

Christmas and New Year have come and gone and you are not yet with us, and stranger still we have not yet heard from you. I thought surely have a letter from you for our Christmas gift....I can never help recalling other and happier Christmas dinners in our younger days. My thoughts reverted to the time when we used to run by your side to the stores to get our "Christmas boxes"—when we used to jump up at daylight and say "Christmas gift!" to everybody in the house and when Christmas was the day of all others in the year to us. [The custom in those days was for children to shout "Christmas gift!" when they woke up or they would not get their gift.]

We had the Rowlands, Mr. Harbaugh and Mr. and Mrs. Norvell to dinner, a very quiet party and in the evening with a dozen or so of our

special friends and plenty of eggnog we were very merry. We had some Tableaux which were pronounced vastly pretty, Laura and I with Mr. Cass [Lewis Cass] *being the actors.* [Tableaux or tableau vivant is French for "living picture." The term describes an art form of the nineteenth century that used costumed actors posed behind a theatrically lit gauze screen to represent famous events of the Bible, history or famous paintings. Throughout the duration of the display, the people shown do not speak or move.]

...I wish you could have seen our Tableaux. I'm sure you would have thought it a pretty amusement. We represented different pictures and having a large frame with a thin gauze before it (to aid the illusion) with a skilful [sic] *arrangement of the light you have no idea how pretty the effect is.... After they were concluded we finished the events with Blind Man's bluff, Puss in the corner and various other noisy games suitable to the season. Just fancy the Hon. Ex-Senator Norvell playing Puss in the corner, and Maj. Forsyth too! And they entered into it with such spirit!...Miss McKinstry has been (and is still) with us and all my time has been occupied with her. In the five weeks she has been here we have not passed a day or eveng* [sic] *without going out or having company, the town has been so gay that we have often had several invitations for the same eveng. She has been delighted with her visit, everybody has been so attentive and we are happy that she is so pleased....*

Ever Your Most Aff.
Emily V. Mason
PS You will laugh when I say in my P.S. Please bring me a pr. "shoes" (slippers). Those I sent for last fall were too small and I had to give them to Laura, the walking shoes fit but I have no others for eveng tea drinkings. I wear No. 4.

Chapter 2

FRENCH CHRISTMAS IN DETROIT HISTORY

While the Protestant denominations were slow to adopt Christmas as a religious holiday, Roman Catholics had always celebrated it. For one hundred years after its founding, Detroit was a Catholic town, starting with the establishment of the city in 1701. In a way, Detroit was founded on Catholicism; in 1632, twelve years after the Pilgrims established Protestant churches on the East Coast, Jesuit and Sulpician missionaries began exploring the West, looking for a place to start their church. This didn't happen until 1701 at Detroit's founding. However, even by the 1830s, Detroit was still essentially a French town, as described by Alexis de Tocqueville in his journeys across America in 1831:

> *This place, founded by the French, still bears many traces of its origin. The houses are placed and shaped like those of our peasants. The Catholic bell-tower with a cock on top rises in the middle of the hamlet. One might think it a village near Caen or Evreux.*
>
> *Many French names on the houses; French bonnets* [women's hats]. *We went to see Mr. Richard, the priest in Charge of the Catholic church in Detroit. We found him busy teaching at school. An old man whose religion seems to be ardent and sincere.*
>
> *We could not contain ourselves for joy at having at last discovered a place to which the torrent of European civilization had not yet come.*

In the 1830s, de Tocqueville claimed there were about two to three thousand inhabitants in Detroit.

Here is another description of a street in Detroit during the French era, an excerpt from Orlando Wilcox's novel *A Shoepac Recollections; a Way-side View of American Life*, published in 1856:

> *As he sauntered along up the street, he would see old-fashioned buildings, stores and dwellings forming a promiscuous row, with high gable and dormer-windows, roofs peaked like Vandyke hats, with their edges notched and painted red, and doors paneled into four parts, and opening by subdivisions, like modern window shutters. Motely groups, consisting of French, Americans, and Indians sit with their sociable pipes....Peeping into the halls and rooms as he passed, he might here and there discern a carpet, but generally the floors were covered with Indian mats. The shops would be filled with bales of furs, gaudy-colored calicoes, known as Indian calicoes, mococks of sugar.*

A Detroit Christmas in the Early 1800s

While the Catholic French habitants in Detroit did not celebrate Christmas Day as we do today, they began on Christmas Eve. It was a serious and quiet night of miracles for people who were passionate Catholics and rich with traditions, superstitions and magic. Some of the activities are listed below:

The revelation of hidden treasures—it was believed on this night that sands on the oceans, mountains,\ and valleys opened up in the moonlight to reveal treasures hidden underground.

One thousand Hail Marys—French mothers would recite one thousand Hail Marys on Christmas Eve while preparing the Reveillon feast for that night. This would give them the chance to ask a small favor of the Virgin Mary for one of their children or their husband.

Farm animals talk—It was also said that on the stroke of midnight, farm animals acquired the marvelous and unusual gift of speech. Oxen, cows, horses, pigs and poultry began to speak French to one another and to exchange strange secrets about humans, particularly their masters. Anyone who risked spying on the animals could be struck dumb or, worse still, face even death.

Farm animals kneel in worship at midnight—Another belief claimed that at midnight, farm animals kneel in the stable to worship the Infant Jesus because it was believed that Jesus was born at midnight.

Dead rising up—On Christmas Eve, the dead rise up from their graves to kneel at the cemetery cross where they are buried. A former priest says the

prayers for the Nativity aloud, and the dead respond reverently. Once this is finished, the dead rise and look forlornly at their village and houses where they were born and silently return to their graves.

GIRLS LEARN THE NAME OF THEIR HUSBANDS—Through a rather dangerous custom, girls would melt lead and let the drips of hot metal fall through a key ring and into cold water. Once cooled they would see the initials of their future husband, his profession and his personality and looks. Or, much less dangerous, a girl would set a bowl of water on a windowsill. On Christmas morning, when it had frozen, she could study the loops and whorls in the ice to discover her future love.

French Canadian Christmas Eve midnight mass was, as social historian Friend Palmer noted in the 1820s, "most imposing." Catholic churches like Ste. Anne's were known for their elaborate and beautiful creches, a scene of the manger. Theirs was called *The Crib of Bethlehem*, and it was erected at the end of one of the side aisles. Palmer described it as "a most elaborate affair, resplendent with lights profusely decorated with evergreens and flowers." The miniature statuettes of animals, baby Jesus, Mary and Joseph, shepherds and three wise men—which in France are called *stantons*, or "little saints"—had a long history in France in the south and southwest, where many Detroiters traced their ancestry. In Quebec, sometimes the stantons were made of beeswax. In France, traditional stantons were placed by strict rules: the donkey was always placed on the right of Jesus and the ox on the left. Stantons went beyond the figures listed above and included Lou Ravi, the village idiot; a miller on a donkey; the bohemian, who is a tramp in search of a dirty trick; a blind man; and his son. There were many more figures, all of which villagers of the day could relate to and understand, to show the human side of the holy event, making it endearing to all people in the church. Palmer pointed out that the Ste. Anne creche was used as a teaching tool for children and adolescents to point out that even the "Divine Lord and Master began as a tiny helpless babe."

In this era, each family had their own dedicated pew in the church, which was well-lit by all the candles and decorated for the occasion. (To this day, you can see the names of French families hand-inscribed on tiny place cards at the end of each pew at Ste. Anne's.) High mass would be performed, then low mass. The priest would recite prayers, and the congregation would sing old Christmas songs, some dating from the Middle Ages.

To take to the midnight mass, women took turns baking *pains bénis* "blessed bread": five loaves of bread and twelve "cousins" or small cakes, which were shared with the congregation to show Christmas love and unity.

After mass, families bundled up and walked home through the cold night. They dragged in the enormous yule log, sometimes an entire tree stump with roots, which filled up even a large open hearth. The yule log could only be lit with a piece of the previous year's yule log. Saving a piece of the yule log was important, since burning a fragment of the yule log during a thunderstorm protected your house against lightning strikes.

With the yule log burning, the Reveillon (the "awakening") feast began at midnight. The family would string up a dressed turkey on cord to hang and turn and basted as it roasted in front of the hot fire. A common Christmas dish served was a *tourtiere*, a meat pie with a combination of beef, pork, veal or game. The meat was cut into cubes and seasoned with

Pere Noel bringing gifts. *Wikipedia*.

salt, pepper, cinnamon, sage, thyme, cloves, garlic, savory or other spices. Advent, which runs from the end of November for four weeks, was a time of fasting and abstinence, so the midnight meal was welcomed after that. Common holiday desserts included a nutmeg-flavored egg tart, a *tarte à la farlouche* (molasses pie), tallow pie, sugar pie, white or apple cider vinegar pie, cookies and Savoy cakes.

After Reveillon and throughout the night, a burning candle was kept at the window of a home in the hope that the Virgin Mary might see it as she walked through the night. Christmas Day was a laid-back affair with families together and relaxing.

The most popular day of the Christmastide season, at least for children, was New Year's Day, which was when the children would receive their gifts. In the early days, the custom said it was the baby Jesus who brought gifts to the children; later, it was Pere Noel.

Children put out their shoes by the fireplace and filled them with carrots for Pere Noel's donkey Gui (French for "mistletoe") before they went to bed. Pere Noel took the offerings and, if they had been good, left them

small presents in their shoes, traditionally candy, money or small toys. Pere Noel was accompanied by Pere Fouettard (French for "the Old Man Whipper"), a sinister figure dressed all in black who spanked those children behaving badly.

JOUR DE L'EPIPHONIE OR THREE KINGS DAY

Epiphany, the twelfth day after Christmas, celebrates the three kings who traveled to Bethlehem to pay homage to the infant Jesus and is the final celebration of the season. Later in the nineteenth century, evening Epiphany dinner parties were common among adults, as described by Marie Caroline Watson Hamlin in her book *Legends of Le Detroit*, published in 1884.

For French Detroit families, *La Fête des Rois* (Feast of the Kings) was celebrated on January 6, a final holiday meal to be shared by the family, at children's parties, with friends at dinner parties and even in restaurants and taverns. A *galette des Rois* (puff pastry, pate feuillette filled with frangipane, a type of almond paste) was served for dessert. A small trinket would be hidden and baked inside the galette, originally a black bean but by the nineteenth century a tiny porcelain figurine. It is called the *feve* ("broad bean"). Today, people in France collect feves, and the old and rare ones can be worth a lot of money. The galette was cut into portions equal to those participating; then the youngest member of the family climbed under the table. He or she was asked, "Who gets this piece?" and the child called out the name of the person to get the next slice, all to ensure random impartiality. Whoever found the "treasure," the bean, would receive hearty congratulations as "king" and a small gift.

In taverns, the game got a bit more raucous. When a man found the bean, the tables of the entire tavern applauded and cheered.

"The King drinks! The King is handsome!"

If a woman found the bean, she, too, received cheers and calls of "The Queen!" Then the well-wishers called out to her, "Choose a king!"

She must pick a man but could not name him, only by description: "I choose the man with the tiny mustache!" or "I choose the boy with the red hair."

The nominated King then bowed low as all the tavern shouted out, "The King drinks!"

After the meal, friends, family and neighbors gathered to sing, dance and play music with violins, accordions and harmonicas.

Marie Hamlin described a dinner party in her story of the "Eve of Epiphany" that takes place in 1801 in Detroit. The scene of the Epiphany cake cutting follows:

It was on the eve of one of these, the Epiphany, that in a hospitable old mansion on the present site of Windsor was assembled a brilliant party of stately dames, fair demoiselles, and courtly cavaliers. There seemed to be some latent chord of sympathy between these brave Scottish highlanders and the French, for intermarriages were a frequent occurrence.... The table was set for supper which was followed by games, fortune telling etc.... The large Epiphany cake was cut by the host, each lady present taking a piece. It was then customary to put in it a ring and a small white bean. The lady to whose lot the ring fell was crowned queen. The holder of the bean gave the entertainment the following year, and acted on the present occasion as Maid of Honor. Madam Fairbaine found the ring, and Julie Maisonville the bean. It was then necessary for the queen to select a king.

The French habitants in Detroit and along the waterfront were a lively, gregarious bunch who loved to push back the tables after a meal, pull out a fiddle and dance, sing carols and tease and laugh together. Despite the harshness of living, winter darkness and isolation, these French seemed to thoroughly enjoy the Christmas season and each other's company.

Chapter 3

CHRISTMAS TREES

The Michigan Christmas Tree Growers Association claims that the first recorded Christmas tree dates to 1510 in Latvia. Men of the city decorated the tree with roses and then set fire to it. The idea of Christmas trees as we think of them today came out of Germany. It has been vaguely claimed that Martin Luther, after a winter walk on a moonlit night, was so moved by the thought of God he believed words could not capture his experience, so he put up a small tree in his children's nursery and decorated it with lit candles. Christmas trees were adopted in the United States and Detroit in the 1850s. It is said the first Christmas tree was set up by a German immigrant named August Ingard, who had emigrated from Germany to live in Ohio. He supposedly set the tree up and decorated it on his front porch. It was such a hit in his neighborhood that others began to copy him in subsequent years. (Perhaps this also started the love of Christmas house decorating.) Early trees were small, set up on tables as large centerpieces or in the entrance of the house. Large trees didn't gain popularity until the late Victorian years.

"Smear the Tree in Mucilage..."

The first local Christmas tree to be announced in a Detroit newspaper was in 1852. Christmas trees were set up and decorated for sale in the Fireman's Hall to benefit the Mission Sunday Schools of Detroit. Demand

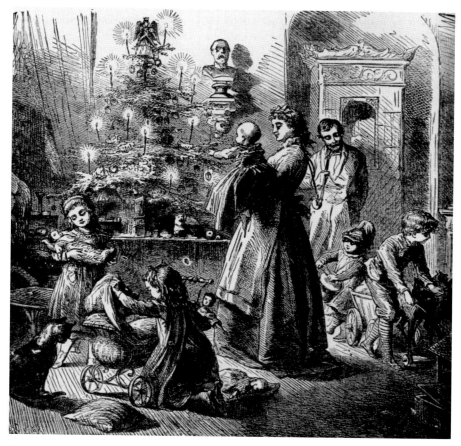

Tabletop Christmas tree lit up with candles in the 1890s. *Wikipedia.*

for Christmas trees grew every year, especially at the start of the twentieth century. In 1908, fifteen thousand trees were reported sold; in 1910, thirty thousand were sold, and in 1912, Detroiters bought seventy-five thousand trees. At that time, Detroiters preferred spruce over all other pines; in other parts of the United States, balsam pines were preferred. Also popular were greens sold as roping and wreaths. Holly, which came from Delaware and Virginia, was most in demand, as was something called "ground pine," which was harvested in Wisconsin and Minnesota. Ground pine is not a pine. One species is in the mint family, while another is a type of fern but is bright green and used for roping and wreaths.

Christmas trees were not always easy to find before the concept of tree farms. They came from northern Michigan and Canada, while some were

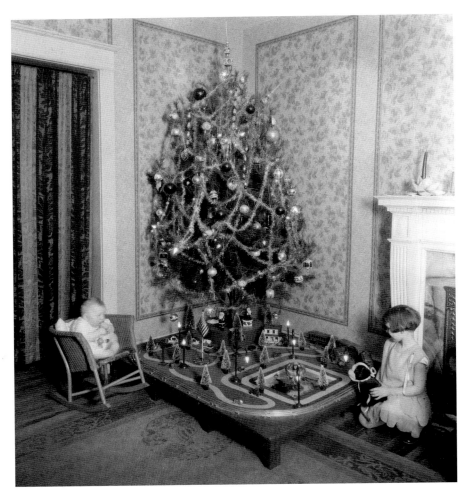

A Christmas tree in the 1910s. *Library of Congress.*

shipped in from Vermont. Forest fires ravaged landscapes, and where land was reforested by state agencies, harvesting trees in big quantities was restricted. Families or individuals would go out into the woods and harvest small trees, which at the time were regarded as useless. They would load them up and take them to Detroit, where they were sold downtown, as described in 1901 article:

> *In some sections where the fir is especially prolific, the cutting and preparing for market of Christmas trees, is made the occasion a festive gathering… whole families going into the woods and taking their dinners along….A*

man cuts the trees close to the roots and a boy or strong girl with a sharp hatchet clip away at the few dead branches near the base. Women or boys tie the trees into bundles of a dozen each, binding them with strong cords then the harvest is piled into hay racks and taken to the nearest railroad station.
Detroit Free Press, *1901*

Buyers were finicky about their Christmas trees, disdaining dry trees or misshapen trees, which were more common then due to their wild origins. It was a risky business for the tree suppliers as Christmas came closer and they were sitting on hundreds of unsold trees. Since the trees cost the sellers nothing other than their labor, setting prices was like a free-for-all, with some nearly giving trees away. When trees became scarce, people would pay exorbitant amounts for a tree, even entering stores and trying to buy the trees decorated in the shop windows.

This led a Detroit businessman named G.S. Ferguson to a radical idea in 1909—a Christmas tree farm. He formed the Evergreen Tree Company and planted fir trees in Alcona County (near Lake Huron) on eighty acres of land. His initial reason for doing so was not to grow and sell Christmas trees. On a trip to Paris in 1900, he learned that a Parisian pharmaceutical company would pay sixteen dollars a pound for evergreen fir sap. It was later that he began getting requests from around the United States for small trees for Christmas. It was so successful he immediately expanded from eighty to six hundred acres. He claimed he could never meet demand and encouraged others to open Christmas tree farms.

Prior to electric tree lights, people used Christmas candles or, as they were called, "tapers." They were attached to the tree by melted wax, glue, special pins or small metal cups. Sometimes creativity was called for when decorating with candles, as described in this article:

Dainty little baskets that can be used to hold candles on the tree…are fashioned from pliable twigs from the pine tree after the needles have been stripped off.…The tips of every two twigs are crossed and wound with fine wire, while the lower ends are interwoven. The bottom is formed by four twigs, each four fifths of an inch long, crossed in the shape of a star. The handle is a twig four and a half inches long, fastened on the bottom and wound at the sides with wire. The two long pieces of the frame measure four inches each. The two cross pieces measure two and two fifths inches, two inches, one and three fifths inches, and four fifths of an inch.

It's hard to imagine a more maddening Christmas activity than that described in the previous excerpt, and it should have ended, "Now, proceed to make fifty more to fully decorate the tree."

People also put tapers on wreaths and roping. Open flames on a real tree were perhaps the most dangerous Christmas idea ever conceived, especially after Christmas, when the tree began to dry out. On top of this, people decorated the floor beneath the tree with cotton batting sprinkled with silver-colored confetti to look like snow. Sometimes they smeared mucilage (a type of glue) on the tree branches, sprinkled sugar on the tree and surrounded the candles with cotton covered with sugar to look like snow.

> *A very beautiful effect is following King Winter's mode of decoration. For this purpose, bits of cotton wool are gummed on the branches, representing snowflakes. The foliage is then smeared here and there with mucilage over which granulated sugar is strewn, so that the tree looks like it was covered with snow and hoar frost.* Detroit Free Press, *1891*

It was popular to use highly combustible, sometimes exploding ornaments made from aniline dye, discovered in 1856, which produced a rich purple color, universally popular during the Victorian era. It also produced toxic fumes when burning. Celluloid ornaments were popular as well, also extremely flammable. On top of this, many homes from the Civil War to the twentieth century were lit with gas—"illuminating gas." The gas lighting system comprised thin pipes that came out from the wall about one foot and angled upward. At the pipe's end was a jet nozzle, which emitted an open flame. Families loved to loop pine roping around the pipes of the gas jets. Once the tree was lit, the gas light was turned down for dramatic effect. After experiencing the beauty of the Christmas tree lit with candles in a darkened room, the gas was cranked way up to bathe the room in bright light and "capture the spirit of Christmas"—occasionally catching the roping on fire. Disasters were inevitable.

> *213 East Palmer Street was damaged to the extent of $200 by fire at five o'clock yesterday afternoon. The blaze was caused by a Christmas tree catching fire from a candle.*

> *A Christmas tree loaded with inflammable ornaments and candles caused a six-story building to burn down the Alexander Student building.*

A false beard worn by Burritt M. Tuttle, judge of the town court, who was enacting the part of Santa Claus at the Christmas Celebration at the Methodist Church caught fire from the Christmas tree candles and Judge Tuttle was severely burned. The church was threatened by fire and a panic was prevented with great difficulty.

It had grown so dangerous that it became an annual Christmas tradition for the Detroit fire marshal to issue his fire warnings. Here is one from Fire Marshal Gabe Coldwater, 1919:

The use of celluloid ornaments and cotton to represent snow on trees is a great menace.

Lighted candles and children in highly flammable dresses effect a combination that is very likely to prove disastrous.

Open lights on trees should be watched the entire time they are burning. Handling or touching the tree may cause the decorations to fall on a lighted candle.

When Christmas greens are dry they are extremely dangerous. They should not be left in the house more than one week after Christmas.

The use of greens, harvest specimens, leaves, etc. either natural or artificial, and other materials such as scenery, cheesecloth, draperies, tissue paper, and cotton bunting are decidedly objectionable from a fire hazard point of view.

In crowded stores and places of assemblage the danger of panic and loss of life in the event of fire cannot be exaggerated.

In 1909, Detroit's Fire Chief Broderick summed up his views succinctly: "Don't have a Christmas tree at all!…The worst of it is they go up like tinder once they get a good start."

Fires were so common that people kept a bucket of water near the tree to put out fires, but the end of Christmas tree candles was fueled by the insurance companies, stating in contracts that Christmas tree fires were a "knowing risk." By 1908, insurance companies had started to refuse to pay for damages that were caused by Christmas tree fires because there were so many of them.

Michigan Christmas Tree Growers Association states that nearly twenty-five to thirty million trees are sold in the United States each year. Michigan is the third-largest producer of real Christmas trees in the country; 10 percent of the country's Christmas trees are produced in Michigan. The top-selling species are scotch pine, Douglas fir, balsam fir and white pine.

THE SINKING OF THE CHRISTMAS TREE SHIP

The three-masted schooner *Rouse Simmons* was built in Milwaukee in 1868. With a crew of seventeen men, it carried lumber from Manistique, Michigan, across Lake Michigan to Chicago for two companies. In 1910, the ship was purchased by Herman Schuenemann, and as captain, he continued the work of hauling lumber to Chicago but added a holiday twist. As the Christmas season began, Schuenemann sent his crew into the forests of Manistique to gather thousands of small trees, which were then loaded onto his ship for the last trip of the year to Chicago as Christmas trees. For added panache, he mounted a Christmas tree at the top of his mainmast as he sailed across the lake. He sold the trees from his boat at the Clark Street Bridge on the river. It became a Christmas event in Chicago to go buy a tree off Schuenemann's ship, which was soon known as the "Christmas ship," and he became known as "Captain Santa."

On November 22, 1912, with 5,500 trees on board, the *Rouse Simmons* headed for the last run to the Windy City. The weather was turning cold and windy, but the captain wanted to get the trees to Chicago before Thanksgiving. Temperatures continued to plummet, and winds grew to a sixty-mile-per-hour gale force, coating the deck with ice. The Coast Guard off Wisconsin could see the ship was floundering, and it eventually went down. All the crew, including Captain Santa, were killed. In 1924, Herman Schuenemann's papers were found wrapped in an oilskin, and a bottle with a message from first mate Charles Nelson read: "These lines were written at 10:30p.m. Schooner R.S. ready to go down about two miles southeast of Two Rivers point, about 15 to 20 miles offshore. All hands lashed to one line. Good-bye." Further evidence of the ship's sinking was produced soon after by commercial fishermen off Two Rivers Point reporting their nets partially filled with pine needles and parts of the small trees.

The ship was accidently rediscovered in 1971 by a wreck hunter, William H. Cohrs, an investment banker from Indianapolis. He was looking for something else and found the *Rouse Simmons*. Divers to the wreck could see Christmas trees in the hull. Interviewed in 1971, the wreck hunter said, "That was a kind of interesting dive. When you first go down and shine your light in the hold and there are all these Christmas trees still there. The needles have all gone, skeletons of trees. It's kind of spooky. They never recovered anybody from there. There were no bodies found."

On Christmas 1912 in Chicago, a tree stood on the Clark Street Bridge covered in black crepe to honor the memory of the captain and his crew

of sixteen. Schuenemann's wife, convinced her husband had lost his life, chartered another schooner, the *Relief*, loaded it with Christmas trees; and made it to Chicago, where she set up the stand at the Clark Street Bridge to sell the trees. There was apprehension that there would be a shortage of trees with the ship's sinking. Oddly enough, Schuenemann's brother August Schuenemann and a crew of five others had lost their lives fourteen years earlier in Lake Michigan, when the two-masted schooner *Thai* sank, laden with Christmas trees.

ARTIFICIAL TREES

A 1975 poll by Michigan State University identified the reasons why consumers were beginning to prefer artificial over natural Christmas trees. The reasons included safety, one-time purchasing and environmental responsibility, but the biggest reason respondents gave pollsters was no messy needle cleanup.

Homemade artificial trees were made by wrapping branches of leafless small trees with cotton to make them look as if they were covered in snow. After Christmas, the cotton was removed with the ornaments and stored away until next year.

FEATHER TREES

The first commercially produced artificial trees came from Germany as early as 1865 and were made from goose feathers. Artificial trees became popular because the high international demand for natural pine trees was deforesting the country and the German government was putting limits on the number of natural trees that could be harvested. Scholars claim the first feather trees were commissioned by glass ornament makers in Lauscha, Germany, to display their Christmas ornaments; they were fearful that limits to natural trees would harm their business. Goose feather trees were created using actual goose feathers. The feathers were dyed green at first and split, then glued onto wire to form branches. Those wires were attached to a large dowel that made up the center trunk, and the base was a block of wood. Often, the tree branches were tipped with artificial red berries, which acted as candle holders. The branches were separated with space to offer room for plenty of ornaments and offer safety with lit candles; it gives these antique

trees a spindly look, which collectors find charming. Later, trees in the early twentieth century were dyed other colors such as white, yellow, blue and red. These became quite popular in Germany and soon spread throughout Europe and were sold in the United States. They fell out of favor after World War II but are regaining popularity as an alternative to plastic trees. Several American companies continue to make the trees today.

ALUMINUM CHRISTMAS TREES

The iconic aluminum Christmas tree. *Wikipedia.*

The 1950s saw the rise of the iconic aluminum Christmas tree, the first artificial tree to be commercially successful on a massive scale. It seemed to catch the American midcentury futuristic ranch house vibe. It was basically aluminum foil adhered to wooden dowels, which you stuck into the central pole, and it made a tree shape. You could not put electric lights on the tree due to possible electrical short circuit and fire, so manufacturers sold a rotating color wheel that shined a light through a plastic disc tinted with alternating colors that lit up through the tree's bright metal branches. If you were really cool, you had a motorized rotating stand for the tree to turn as well.

The aluminum tree emerged in 1955. They were first manufactured and sold by Chicago Coatings but really took off in 1959, when they were made in Manitowoc, Wisconsin, by the Aluminum Specialty Company. For a decade, 1959 to 1969, the company produced one million trees. It sold for $25. The television classic *Charlie Brown Christmas Special* soured Americans on the idea of the aluminum tree. In the special, Lucy wants to buy a big aluminum tree for the school's nativity display, but Charlie passes the gaudy, gigantic aluminum trees and opts for the tender, more spiritual plain real tree, droopy and dropping needles everywhere. The aluminum trees became a prime example of the overcommercialization of Christmas. Americans got the message and ditched their trees. For ten or more years, you could buy them in garage sales for as low as a quarter. Of course, like all things, the aluminum has become collectable, especially in online auctions; in 2005, someone paid $3,600 for a rare pink aluminum Christmas tree.

ELECTRIC CHRISTMAS TREE LIGHTS

Thomas Edison, the inventor of the first successful practical light bulb, created the first strand of electric lights. During the Christmas season of 1880, these strands were strung around the outside of his Menlo Park Laboratory. Railroad passengers traveling by the laboratory got their first look at an electrical light display. But it would take almost forty years for electric Christmas lights to become the tradition that we all know and love. The public did not trust electricity, and electric tree lights did not become widespread until the 1930s.

The first known electrically illuminated Christmas tree was the creation of Edward H. Johnson, an associate of inventor and friend of Thomas Edison. While he was vice president of the Edison Electric Light Company, he had Christmas tree light bulbs made specially for him. He proudly displayed his Christmas tree, which was hand-wired with eighty red, white and blue electric incandescent light bulbs the size of walnuts, on December 22, 1882, at his home on Fifth Avenue in New York City. If that wasn't enough, it also revolved. Local New York newspapers ignored the story, seeing it as a publicity stunt. However, it was published by a Detroit newspaper reporter, and the rest of the nation picked up on the story. Johnson became widely regarded as the father of electric Christmas tree lights.

General Electric (GE) purchased the patent rights for Edison's light bulbs in 1900. By 1903, GE had begun offering preassembled kits of Christmas lights. Up until then, stringed lights were reserved for the wealthy; the wiring of electric lights was expensive and required hiring the services of a wireman, whom we now call an electrician. According to some, to light an average Christmas tree with electric lights before 1903 would have cost $2,000 in today's dollars. Some early sellers of electric lights suggested people rent them instead.

Within twenty-five years, the demand for electric Christmas lights was on the rise, with fifteen separate companies selling their own version of them. NOMA was formed in 1925 as the National Outfit Manufacturer's Association, a trade group made up of the fifteen smaller manufacturers hoping to gain competitive advantage by combining their manufacturing, marketing, distribution and purchasing power. In 1926, the association's members officially incorporated as the NOMA Electric Corporation and began selling NOMA-branded light sets by 1927. They became the largest Christmas light manufacturer in the world and would dominate the industry until the 1950s and 1960s when GE-imported lights from Asia began

competing with cheaper products. GE called the lights Merry Midget mini lights. They were smaller, cheaper and more outdoor-friendly, so people began lighting their houses all over the country with greater intensity. By 1986, industry trade organizations stated that of the 150 million sets of Christmas tree lights bought by Americans, half were produced overseas in Taiwan, Hong Kong, China and South Korea. The share of the imports in Christmas lights from the whole of Asia has remained stable and stands at 91.8 percent in 2020, as other Asian countries, Cambodia in particular, have grown their exports of Christmas tree lights.

BUBBLE LIGHTS

By the 1940s (after World War II), the leaders of NOMA saw that the Japanese were already producing high-quality Christmas tree lights, so NOMA started to focus on a product it could patent protect. Carl Otis invented a bubbling lit-up glass tube used for commercial signs that was patented in 1939, called "Display." Once the patent was granted, he submitted a second patent application in 1941 for Christmas tree lights he called "Ornamental Illuminating Device"; the liquid that produced the bubbles when heated by the light bulb was methylene chloride, which has a low boiling point. That patent was granted in 1944. Otis sent out offers to buy his patent to Christmas light manufacturers, and NOMA was the only one to respond. It bought the patent and hired Otis to develop the concept further for mass production. NOMA's "Bubble Lites" were a success, selling twenty-five million bubble lights in two years. Carl Otis was paid three cents per bulb in royalties.

A competitor of NOMA's came out with a nearly identical bubbling light, and both companies went to court for infringement. As it turned out, Otis's patents were invalidated, and NOMA terminated its license with Carl Otis and stopped paying royalties. The company's relationship with Otis finally ended in 1950. While other companies sold bubbling lights, NOMA dominated the market and sold many, many millions of the lights, some of which continue to bubble today.

LED TAKES OVER

While LED Christmas lights cost more money up front, they save money over time, since LED lights use 75 percent less energy than incandescent

lights. Because LED lights use less energy than incandescent bulbs, they reduce greenhouse gas emissions, giving the environment a little help. LED lights also last longer, meaning you don't have to replace a strand of them as often. When temperatures drop below freezing, incandescent lights can actually burst. But LED outdoor Christmas lights work just fine in cold temperatures; they actually get more efficient as the thermometer drops. LED Christmas lights get high marks when it comes to durability. In tests, LED bulbs didn't burn out after more than four thousand hours, while standard light-string bulbs burned out at a rate of one to two per strand in less than half that time.

THAT OLD DETROIT CHRISTMAS LOOK

NOMA Christmas tree lights for that classic retro look. *Author's collection.*

While Christmas lights are now twinkling "mini" and more frequently LED lights, the Christmas lights your grandparents or great-grandparents used— the Detroit vintage look—were likely made by NOMA and were the large incandescent cone-shaped bulbs, called C9s, on strands of eight to twenty-four bulbs. These are the light bulbs that started the mass purchase of Christmas lights, the lights that look great wrapped around mirrors in cozy, old bars. Even though it is well over one hundred years old now, the technology of these lights remains practically the same. Today the industry calls them "retro" lights.

DETROIT'S CHRISTMAS TREE

Giant municipal Christmas trees appeared because electric lights made them possible. Detroit's first municipal tree was raised in 1912 by the order of Mayor Oscar Marx. It was set up on Woodward Avenue opposite city hall, and the tradition for three years was to have Mayor Marx's son "Junior" throw the switch to light up the tree.

By the third year, the tree was set up in Grand Circus Park instead of in front of city hall because the choral societies complained that "clatter" from Cadillac Square was a distraction for their singers. The mounted police led one thousand children dressed in costumes and singing Christmas carols

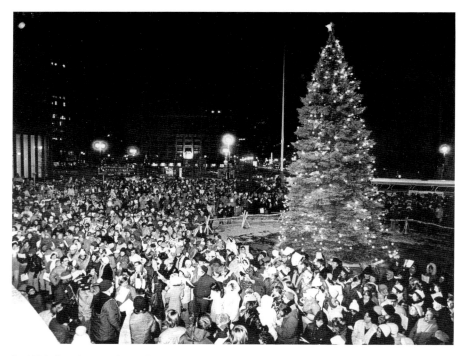

In 1976, five thousand people gathered in 17-degree weather for the eleventh annual Action Line Christmas Carol Sing. *Author's collection.*

as they marched from city hall to Grand Circus Park through a miserable snowstorm. They were followed by ten thousand people who all gathered around the tree at the head of Washington Boulevard. After lighting the tree, the mayor watched through the windows of the warm lobby of the Statler hotel.

By 1920, the tree had returned to city hall, and the ceremonies and pageantry continued to grow. Once again, one thousand singing children marched from Grand Circus Park south on Woodward to city hall with mounted police; the largest policeman dressed as Santa Claus. However, now the Girls Patriotic League band played with them, and children of the American Legion, Boy Scouts, Girl Scouts, Campfire Girls, a fire department float and the Cass High School band came along as well. In 1922, ten thousand carolers from eight hundred separate groups wore red capes and red caps trimmed in white, sang surrounding the city tree, then dispersed. Any house that displayed a lit candle in the window would be caroled by one of the singing groups. Those homes that displayed gold stars, which meant a father or son were killed in World War I, heard

special songs to honor their sacrifice. Singing groups were also sent to the hospitals, hotels, theaters and the Michigan Central Depot. That year, the city permitted eighty-five prisoners at the Detroit House of Correction to be released for "Christmas time pleasures"; the inmates were expected to return to prison the day after New Year's Day.

In 1928, Santa Claus arrived at the tree ceremony by airplane, one of Detroit's own Stinson Detroiter SB1 aircraft made in Northville. Santa departed from Northville Stinson airport and flew over Detroit at midday. After landing in Detroit, he and the plane were driven to the city Christmas tree site, where the Stinson plane was displayed near the tree through the entire lighting ceremony.

As years went on, the big trees were donated by individuals to the city. In 1935, a tree was donated by Robert Musgrave, who lived in the town of Harrison. It was on his forested property. The problem was that it was in the middle of a swamp, and the American Legion team sent to bring it back to downtown couldn't get within a city block of it. One member of the team was interviewed at the time.

"Boy oh boy, that was some job," said Jack Roehl. "We had to cut a lane through the swamp. Then we had to put down a stretch of corduroy road. We made a skid and hauled it out with block and tackle."

In those days, the tree was decorated by the fire department using a hook and ladder.

In 1946, Hans Schierlinger, retired employee of the Detroit's Department of Parks and Recreation, was honored for serving as Santa Claus since 1915. He went on to play Santa until 1955. In 1934, he donated a sixty-foot tree to the city from his property in Grayling.

The tree lighting ceremony continued year after year. In 1957, Soupy Sales hosted the televised lighting, and local celebrity Fran Alison read the "Christmas Story." Soupy returned the following year and was joined by Julie Harris, renowned actor of New York theater and movies such as *East of Eden*, who was born and raised in Grosse Pointe. Perhaps her most famous role was in *The Belle of Amherst*, in which she plays Emily Dickenson. That Christmas she narrated "The Story of Our First Christmas" at Ford Auditorium. It's hard to imagine a more unlikely couple of Emily Dickenson and Soupy Sales, but hopefully, it worked.

By 1962, Detroit's Christmas Carnival had started in Cobo Hall. It was conceived of by Mayor Jerome Cavanagh as a fun, free event for children and parents after fire destroyed the Ford Rotunda, which had been a huge draw for families at Christmastime. It featured live animals, free

candy, huge floats from the Hudson's Thanksgiving Day parade, a circus train complete with Bozo the Clown and a theater continuously showing cartoons with Christmas themes. The popular event opened as soon as the city Christmas tree was illuminated; thousands of kids and their parents headed to Cobo Hall. Over the holidays, around 500,000 people went to the Christmas Carnival.

Christmas Memories of Detroit's Celebrities

· ·

Mayor Coleman Young

When Mayor Coleman Young was around eight years old, he got a Flexible Flyer for Christmas.

"It was the Cadillac of sleds, and no child was ever happier than I was. That year I also got my first high-top boots with a pocket on the side for my Boy Scout knife."

Mayor Young answered this question in another interview eight years earlier: "When I was eight or nine my mother confided in me that as I was the oldest of five children, there was no Santa Claus, and in so doing she took me to my grandmother's house, where I got to stay up until midnight, helping them wrap the presents and getting everything ready for everyone else for Christmas. It was wonderful."

All Star Tiger Catcher Bill Freehan

Bill Freehan's most memorable Christmas gift came in 1969, when he had to rush his wife to the hospital to deliver their daughter Cathy at 3:30 on Christmas morning. "I got home just about the time my daughters Corey and Kelly came down to open their presents. I told them, 'Oh, by the way, your mother got you a baby sister this morning too.'"

WJR's J.P. McCarthy, Radio Host

If Freehan was hard to top, Bob Talbot interviewed McCarthy and heard this response. It was Christmas Eve 1962 when his twins Kevin and Kathleen were born. "We thought for a moment of naming them Jesus and Mary, but decided not to, for which Kevin and Kathleen are grateful, especially Kevin."

Dick Purtan, Radio Personality

Purtan remembered a Christmas gift he got as a youngster in Kenmore, New York. "My mother's brother came in and gave me five dollars for Christmas. I immediately ran down to the local record store and bought and old 79 rpm record of the pianist Oscar Levant and the New York Philharmonic playing 'Rapsody in Blue' and 'American in Paris.' Well, my uncle thought that was so neat that he took a shine to me. He had tickets to the Buffalo Bison's hockey games. When he couldn't go, he would send them to me. That's how I got into hockey."

George Pierot, Travel Writer and Television Host of Bold Journey

"The best gift Helen [his wife] and I ever received we gave to ourselves. We were in Bucharest, Hungary, on Christmas Eve in 1919 and ended up in a restaurant that was, well, a House of Assignation. (I was young and beautiful then.) We had our own fireplace, a single bed, and a dining room, and a waiter, who whistled loudly before each course, so we could get our clothes on. I would be immensely flattered if it ever happened again. The best gift I ever gave were a pair of snake skin covered opera glasses I gave to Helen on that trip. I had to keep smuggling then in and out of customs while going all the way around the world without Helen ever finding out. It was the hardest work I ever did."

Sunnie Wilson
Christmas 1955

"After the wedding [for Joe Louis] my New York friends threw me a party in a suite at the Theresa Hotel [in New York City]. Although the room was filled with the festive atmosphere of pretty girls and champagne, I began to think of my friends, a group of fellas who gathered on Christmas—an informal group made up of twenty-five Black men—businessmen, lawyers, and doctors....Each year different members hosted the celebration

at their homes. At midnight on Christmas Eve, we had what we called a midnight lunch, cooked by one of the fella's wives....We would eat and review the year....When I was at my party at the Theresa, amid all the festivities, I began to miss my friends. Without attracting the notice of my New York hosts, I left the room and called a porter to have my bags ready in the lobby. Then I booked a flight to Detroit and arranged to have my friend, Dr. Bennet, pick me up from the airport. Back in Detroit, I made it in time to have our midnight meal. Even among the bright lights and celebrities one cannot forget old friends. When I got to the house where the fellows were having dinner, they all greeted me like a long-lost soul."

Chapter 4

CHRISTMAS SHOPPING

CHRISTMAS SHOPPING IN NINETEENTH-CENTURY DETROIT

An early notice published in 1832 for Christmas gifts promised handmade items; gifts made by hand were less costly than those imported from Germany or France—and also more durable.

> *A great variety of articles, suitable for Christmas presents, prepared by the ladies of St. Paul's church, will be sold Friday evening at the Mansion House, the 21ˢᵗ instant. The ladies and gentlemen of Detroit are respectfully invited to attend. Sale to commence at early candle light.* Detroit Free Press, *December 12, 1832*

However, within twenty years, shopping for store-bought Christmas or New Year's presents had become acceptable and popular.

By 1851, Detroit's population had reached twenty-six thousand, and the city had six hundred brick structures and four thousand wooden buildings. The main shopping area was on Jefferson Avenue. Morrison and Conklin's at 157 Jefferson offered silver dinner sets, pickle dishes, gold egg cups, silver tea bells "with the sweetest tone," toast racks and a knife for any imaginable task, including an ice cream knife. Jeweler Charles H. Dunks specialized in fancy pens, especially heavy gold pens but also writing utensils for the ladies, literally feather-light swan quills. Need a tiny telescope, go to George Schuler's at 160 Jefferson. And the best lapidary in the west in 1861 was Pohl's. Pohl's is where you went to pick up a ring that was set with a Lake

Superior agate or you could just bring in an agate and he would set it into a ring for you as you waited. Need a beaver fur for your wife, get to J.T. Smith's, who also had muskrat sets.

One of the early toy stores was at Wm. Phelps at 85 Jefferson, the Wholesale Toy and Confectionary Store with dolls and doll parts of all sorts. Of doll parts alone, they offered a variety in an advertisement from 1859:

> *Doll bodies, kid and muslin, dolls arms, linen, India rubber, India rubber cloth, Wood, China, Waxed, common doll heads Wood, China, Waxed, Gutta Percha and all sizes, rolling dolls, tumblers, jumping jacks, surprises, animals, birds, fishes of wood, India Rubber, tin, China.*

(Gutta percha was a sap harvested in Malaysia from trees. In feel, it was a soft white material similar to plastic and used in domestic applications and industrial; the early electric or telegraph cables were covered in gutta percha, as it did not conduct electricity. It was also a common material for doll's heads and hands. Sometimes wooden dolls were covered with gutta percha or vulcanized rubber.) And for boys, there were toy hatchets, hammers, drums, guns, cannons and pistols—in short, complete mayhem.

Phelps added at the end of the long list, sounding like a retailer of today, "In short, almost anything in the toy line, and to be sold at the very lowest prices. I shall be happy to show my goods to all who may desire to see them."

THE GOLDEN AGE OF DEPARTMENT STORES

The first department store in Detroit was started by C.A. Newcomb and Charles Endicott. Newcomb arrived in Detroit from New York in 1868 and formed a partnership with Charles Endicott to purchase the dry goods store of James W. Farrell and Brother. They opened their first dry goods store at Woodward and Jefferson in 1868. They did well and a year later moved to the Detroit Opera House on Campus Martius. By 1881, they occupied a five-story building at Grand River and Woodward. Endicott died in 1896, but Newcomb continued with a new corporation. In 1915, Newcomb died, but the corporation purchased an adjacent property and built a twelve-story addition to the existing building in 1918.

Other department stores also opened in the late nineteenth century, such a Heyn's Bazaar. Heyn's Bazaar opened in 1873 on Woodward north of Campus Martius. It was easily seen at night since the store was outlined with

thousands of tiny lights. In 1891, fans were popular items for Christmas. Heyn's sold an enormous variety, from fancy ostrich feather fans with carved pearl handles classified as "bridal fans" to dainty fans for girls at dancing school. Coquettish and novelty fans were popular, as were black fans.

Thanksgiving time is the forerunner for the holiday season and, Heyn's Bazaar is, as usual, in the lead for the most attractive display in the city. Their mammoth main window exhibition of dolls is the most elaborate and extensive seen in Detroit. Every conceivable kind of doll from the ordinary five-cent one to the extraordinary $50 dollar beauty is to be seen in the display. Detroit Free Press, *November 28, 1893.*

C.R. MABLEY'S, 1885

Christopher Richards Mabley emigrated from Cornwall, England, as a twelve-year-old with his family to Toronto, Canada, and on to America, where his father set him up to be a silk merchant. Instead, he opened several stores in Canada, Michigan, Ohio and beyond called Mabley and Company. After initial failure, he opened his first Detroit store on Woodward Avenue in 1870. Six years later, he built a new and larger store on the same site and expanded into women's and children's clothing, then into furniture and appliances on Monroe Avenue adjacent to the Russell House Hotel. While he had a department store in appearance, Mabley set up fifteen separate independent entities in his buildings selling shoes, men's clothing or furnishings. It was the biggest retailer in Detroit and Michigan, and due in part to his knack for advertising, he drew in customers throughout the region and state. Mabley brought along with him to Detroit his trusted and importantly sober apprentice Joseph Lowthian Hudson, who had worked for Mabley in Grand Rapids and Pontiac. Mabley hired Hudson to manage the clothing departments at fifty dollars per week. Hudson even lived with Mabley and his wife for a while. For four years, the Mabley-Hudson team worked well. Hudson learned a lot about customer relations and sale promotions; Mabley was nicknamed the "Merchant Prince." He had a bit of a carnival showman in him, staging tightrope walkers to traverse Woodward Avenue from his stores. He had a four-story building on the east side of Woodward and a second five-story building on the west side of Woodward near Congress Street called Mabley & Company's Bazaar and Shoe House. Mabley featured pie-eating

contests in his display windows and frequently ran a wooden bridge across Woodward for promotions or celebrations such as the Grand Army of the Republic (GAR) convention held in 1891. His advertisements in the newspapers read like a carny barker was shouting at you:

> *In our hat and cap department we have a tremendous stock of fine soft hats, fine stiff hats, medium quality soft hats, medium quality stiff hats, dollar hats, stiff and soft, all shapes, extra value. Caps of all styles, fine seal caps, imitation seal caps, otter caps, beaver caps, cloth caps, chinchilla caps, astrachan caps, plush caps, velour caps, every kind of caps. Ladies' furs in seal, mink, coney, astrachan, squirrel, lynx, martin, Alaskan, m. seal. Come and look through our house before buying presents.* Detroit Free Press, *December 14, 1879*

With the solid and dependable Hudson managing the store, Mabley could indulge in his love of spiritous liquors. He even installed a door from his office to the barroom of the Russell House, where he could usually be found. Mabley was famous for taking the straw hat off a stranger and punching his fist through it, then offering the stunned stranger his card, giving him one free hat of any value at his store, with a smile and a bow. Mabley would also disappear for days on drinking binges, forcing Mabley's wife, Katherine, to tell Hudson to go find him. Mabley's drinking threatened Katherine Mabley's social standing in the city, and it infuriated her.

Mabley's health was deteriorating, so he decided to take an ocean voyage to Europe for three months, knowing Hudson was running the show. Mabley journeyed with Hudson's older brother Richard. Upon leaving, he ordered J.L. Hudson to put up an enormous billboard advertising the store on the front lawn at his Detroit mansion on Woodward. Hudson did this, but when Katherine Mabley saw the sixty-foot billboard she flew into a rage, attacking Hudson physically and showering abuse on him. When Mabley returned home from his trip, Katherine met him on the pier in New York, immediately pouring out her anger at Hudson's shocking behavior. Mabley was no match for his raging wife and took her side when back at the store. With that, the Mabley-Hudson relationship was deteriorating, and J.L. Hudson would soon depart for greater retail glory.

Mabley seemed to have a gift for hiring outstanding people. Along with Hudson was Bruce Goodfellow, who joined Mabley as a manager in 1870. Mabley passed away in 1885 at age forty-nine, and Goodfellow, who had been running the furnishings department in the Russell House Hotel,

The Majestic Building, originally owned by C.R. Mabley in 1890s. *Library of Congress.*

took the reins as president and was so successful that he was soon able to commission the tallest building in Detroit (fourteen floors) as the Mabley-Goodfellow and Company flagship store. However, the cost of the building brought Goodfellow to the edge of bankruptcy.

He surrendered ownership of the building, and the new owners renamed it the Majestic Building due partially to the many letter Ms (for Mabley) cast on doorknobs and carved into the stonework. Mabley and Company took over the bottom eight floors of the magnificent building and opened for business in 1897:

> *At six o'clock this evening the doors of the Mabley-Goodfellow department store will be thrown open to the Detroit public, and an opportunity for inspection of the mammoth undertaking. The first eight floors will be occupied by the company and sublessees and the latest and best of all classes of good will be shown.* Detroit Free Press, *April 14, 1897*

But Mabley's department store was still anemic after investing in the new building, and it soon went under. Its location in the Majestic was taken over

by another store, Pardridge & Blackwell. P&B stayed in the Majestic Building until 1906, when its success led to it building a new store of its own nearby, on Monroe and Farmer Streets.

CROWLEY'S

In the economic downturn of 1907, the store Partridge Blackwell (P&B) was hit hard and went out of business. Joseph J. Crowley, the president of P&B's largest creditor, Crowley Bros. Wholesale Dry Goods, took over the business. Crowley was joined by William L. Milner, who owned the William L. Miner Department Store in Toledo, Ohio. Together, they reorganized the store's management and accounting systems and eliminated the grocery, meat and liquor departments as well as the barbershop. For a while, Crowley and Milner's was the biggest store in Michigan on Monroe and Farmer Streets. Ten years later, it was known simply as Crowley's. By 1915, they had added onto the original building, which extended the store to Library Street. Then came another addition in 1919. The final expansion in 1925 included an eleven-floor warehouse connected by a five-story bridge to the main store.

At Christmas, Crowley's went big. They featured puppet shows and cartoon in their toy department, called Fairyland. It had an enchanted forest. They featured Disney characters, such as Snow While, in 1937. In the 1950s and 1960s, the auditorium was transformed into a holiday festival that had carnival rides, a sit-down snack bar and surprise gifts. In 1951, Crowley's began Lunch with Santa, an annual event where kids could tell Santa what they wanted for Christmas and then receive a mug that said, "I had lunch with Santa." This was the first store in Detroit to feature photos with Santa.

KERN'S

Kern's was the third of the giant department stores downtown along with Crowley's and Hudson's. It was founded by German immigrants Ernst and Marie Held Kern. The first Kern's was on St. Antoine Street at Lafayette in what was then a German neighborhood, and they sold imported fabrics and laces, probably from Germany. After three years, the original store burned, so the Kerns found a new location on Monroe at Randolph. In 1897, the Kerns purchased a five-story building and opened their store on Woodward and Gratiot. Ernst Kern died in 1901, and the operation was taken over by

The famous Kern's clock in Campus Martius. *Library of Congress.*

his two sons, Otto and Ernst. From 1919 to 1928, the store was expanded several times, eventually leading to a ten-story expansion that added 200,000 square feet of floor space. The building had a strong Art Deco style; the inside was spacious and elegant with thirty-foot ceilings, ornate lighting, gleaming mahogany counters, white marble floors and elaborate wrought-iron railings. It had an auditorium, dining room, roof garden and gym for the store's five hundred employees.

For the holidays, Kern's kept it classy. In 1958, Kern's won the Central Business Association's award for best interior and exterior Christmas decorations, with the theme of "Joyeaux Noel." The exterior display included elaborate lighting, large evergreen trees and Christmas colors for their awnings. Their Christmas Toyland had a merry-go-round and Santa.

A Kern's Christmas tradition was to give four hundred orphans a day at the toy department, a talk with Santa and a stocking filled with candy and toys to take home.

J.L. HUDSON'S

The Hudson building was a behemoth at 410 feet tall and 32 floors. Hudson's downtown building towered 25 stories over the Detroit skyline and at one time was the tallest department store in the world. It grew as the city grew, with addition after addition, but it was more than a huge department store. Joseph Lowthian Hudson understood his role as a civic leader. He emphasized customer service that was professional but warm and personable.

J.L. Hudson was born in October 1846 at Newcastle-upon-Tyne, England, the second of four children. His father, Richard Hudson, struggled to stay solvent in as a spice dealer. He decided to see if he could do better in North America and moved to Hamilton, Ontario. After two years, he summoned his wife and children to join him. Hudson was nine; the youngest child was one years old. In Hamilton, he immediately enrolled in school. His father worked for the Grand Trunk Railroad, and Hudson took a job as a telegraph messenger boy. But Richard was restless, so the family moved to Grand Rapids, where he struggled to find work. While in Canada, Richard

HOLIDAY GARLANDS

HUDSON'S, DETROIT, MI

Hudson's main floor of the Farmer Street building on Gratiot Avenue, 1940. *Author's collection.*

had met a fellow Englishman named Christopher Mabley, who owned a men's store. (This is the same Christopher Mabley who eventually owned the enormous eponymous department store in Detroit.) At age twenty-three, Mabley opened a second store in Pontiac, Michigan, so Richard sought his help and was hired in Pontiac. Mabley also hired Richard's fifteen-year-old son as a clerk. He soon realized the teen's honesty and scrupulousness and doubled his salary. Mabley later opened another store in Ionia, Michigan, then a lumber town. Richard left Pontiac to run the Ionia store, of which he was a part owner. Hudson stayed in Pontiac and lived with the Mableys, and he later joined his father and his family in Ionia; however, in 1873 an economic depression closed the lumber trade and forced the store to go bankrupt. The stress killed Richard. Joseph L. Hudson, now twenty-seven, was responsible for the debt.

Despite his financial difficulties, Hudson came to Detroit to meet his former employer Christopher Mabley, who owned a clothing store on Woodward Avenue. He later expanded the store. Mabley was happy to see his dependable clerk again and hired Hudson as manager of the of his new store's clothing department at fifty dollars per week.

The arrangement benefited Hudson, as he learned about promoting with sales and public relations. The energetic Cornish Mabley was that kind of man; he was the first person in Detroit to take out a full-page advertisement in the newspapers. But eventually, Mabley's alcoholism and his wife's abrasive personality forced Hudson to quit. (Hudson was a lifelong teetotaler and never married.) He decided to open his own first store on the main floor of the Detroit Opera House; the clothier Newcomb and Endicott had recently vacated the location. To Mabley's embarrassment, he lost a mass of his employees to join Hudson's new store. Hudson took out a grand opening newspaper advertisement on April 2, 1881. The opening of "J.L. Hudson's clothing, hat, cap and gent's furnishings" featuring the Opera House orchestra and Military Band, was a complete success:

> *How J.L. Hudson entertained the public from 9:am to 11:pm. That it was a grand affair and an event long to be remembered by the thousands who participated in it, and thronged the vast concourse and the store from morning to late evening.* Detroit Free Press, *April 3, 1881.*

By 1888, the store was so successful that Hudson was able to pay back with interest all his Ionia creditors from his father's past bankruptcy. By 1890, the best-sellers at holiday season were cylindrical records for customers'

gramophones, Kodak box cameras, shaving mugs and Uneeda Biscuits, which at Hudson's were neatly packaged instead of being scooped from barrels.

Hudson passed away in 1912 on a trip to England, and while he had no children to take control of the store, he did have four young nephews: Richard Webber, Oscar Webber, James Webber and Joseph Webber. Upon Hudson's death, the Webbers took leadership of the store and would grow Hudson's to become one of the largest department stores in the world. They managed as a team, each bringing his own special skills to the enterprise. With the death of James Webber in 1960, Hudson's grandnephew Joseph L. Hudson Jr., at age thirty, was brought into the management as president.

Beginning in 1911, J.L. Hudson's expanded the downtown store by absorbing adjacent buildings or tearing others down to build on the vacant patch of land. In 1946, Hudson's bought the old Sallan Building, which seemed to cling for dear life at the corner of Woodward and Gratiot, as if the massive Hudson building would engulf it. Hudson's tore down the Sallan building and erected a twelve-story addition to its department store, which officially expanded Hudson's to an entire city block. It also added two stories to the Grand River end and expanded the mezzanine floors in both the Woodward and Farmer Street buildings. This would be the final time the downtown store was expanded.

The building was from the land of the giants with 32 floors, two half floors, a mezzanine and four basements. It had 51 elevators, one of which was big enough to fit an entire tractor trailer. Spacious aisles were richly carpeted; walnut-paneled elevators had uniformed elevator operators quietly announcing the floors and their wares and providing directions to shoppers. (People who visited Hudson's as children at Christmas often recalled the elevators and elevator operators as the most impressive thing at the store.) There were 756 fitting rooms; ladies' restrooms were spacious and well appointed. On the fourth floor, the ladies' room offered 85 stalls. Children's sections were elegant, where children drank from polished brass drinking fountains placed at child height. By the mid-1950s, Hudson's processed 100,000 transactions a day.

A feature in *Life* magazine in 1958 described the immensity of the operations, which sold over half a million commodities from two hundred departments: "anything from jeweled dog collars to baby bumble bees preserved in soya sauce and sugar."

One could find anything at Hudson's, from tulip bulbs to rare Russian antiques. In 1920, in the Antiques Gallery on the eighth floor, Hudson's displayed a priceless collection of Russian antiques collected just after the

Russian Revolution. It described the collection as follows:

> *This exhibit is the first important collection of the Czar's treasures to come out of Russia since the Revolution...made possible through the daring and enterprise of Dr. Armand Hammer and his brother Mr. Victor J. Hammer, New York City, who went to Russia on business shortly after the revolution and spent several years there collecting these treasures.*

Hudson's maintained an import office that sent buyers to cities around the world looking for items that would catch the eye of Detroiters.

There were five restaurants in the building, and they served ten thousand meals a day. In the basement cafeteria, there worked a skinny teenager, Diane Ross, as a bus girl who was passionate about fashion and sang in her church, Olivet Baptist, with her group the Primettes. Eventually, the Primettes became the Supremes, and she would change her name to Diana and record the group's first blockbuster hit, "Where Did Our Love Go."

CHRISTMAS AT HUDSON'S

At Christmastime, the Hudson's thirteenth-floor kitchen was busy preparing 3,000 pounds of plum pudding and 4,250 pounds of fruit cake, both dark and light Scotch Dundee, liked by old-time customers.

On the twelfth floor was Santaland, where there was an array of lights and trees and, of course, Santa himself. Families were greeted by Christmas pixies and a woman called "Christmas Carol" who was there to help manage the nearly 225,000 kids visiting Hudson's Santa.

Also on the twelfth floor was a Christmas carnival with ponies, rides and a small restaurant. Another place for kids was the children-only shop on the fourth floor, called the "Merry Go Christmas" shop. No parents were allowed. Items were between fifty cents and three dollars so that youngsters would be able to afford them, and shelves hung within a child's reach. Teenaged shopping counselors were on hand to help them make choices. Small desks gave kids a comfy place to write out gift cards, and a bar for kids offered milk and crackers to keep them occupied. As *Life* magazine wrote in 1958:

> *While many stores try to make shopping pleasant for everybody, a few go out of their way to make it a lark for the youngsters. The Merry Go Christmas shop in J.L. Hudson's company department store is appealing*

to kids by being off limits to parents. It enhances the youngster's feeling of being in their own world....Hudson's expects 30,000 kids to leave their savings in the shop before Christmas.

THE END OF DOWNTOWN HUDSON'S

By 1954, Hudson's had sales of more than $163 million, which comes to $1.28 billion today. The store's success would peak in the 1960s, as Hudson's expanded into the suburbs, including a location at the now-closed Northland Mall in Southfield.

As more people began shopping in the suburbs and Detroit's population began to decline, Hudson's closed its doors on January 17, 1983, after more than ninety years in business. However, the building would stay open for the rest of the decade since it was the location of the corporate headquarters. In 1990, it was sold by Dayton Hudson Corporation to Southwestern Associates in Windsor, Ontario.

The building was seized by the State of Michigan in 1996 for unpaid taxes and transferred to Detroit's Downtown Development Authority. As urbanists and preservationists attempted to save the historic structure, the DDA spent $12 million to raze it.

At 5:45 p.m. (Hudson's closing time) on October 24, 1998, the massive building was imploded, becoming the largest urban structure to be destroyed, according to Curbed Detroit.

THE NEW AUTOMOBILE AND CHRISTMAS SHOPPING

Some of the traditional Christmas winter activities in Detroit and other cities across the world came to a halt with the emergence of the automobile on city streets.

> *In the days before the advent of the automobile, yesterday would have been an ideal Christmas morning. With five inches of fleecy snow, the sleigh runners should have been slipping and the bells jingling an accompaniment to the shouts of frolickers. As it was, few sleigh riders were seen. The glass fronted touring car or runabout, and the luxurious limousine or electric hansom took their place.* Detroit Free Press, *December 26, 1906*

"The Reindeers' Replacement." Postcard of Santa delivering gifts in a car. *Author's collection.*

Autos were replacing sleighs. Michigan was a leader in the U.S. sleigh manufacturing, but production was dropping: producing 53,180 sleighs in 1904, 32,751 in 1909 and 12,205 in 1914.

But times of transition frequently bring out solutions to both needs. In 1903, it was the Auto-Sleigh, and the one owned by George Lewis of Detroit could be seen cruising up and down Woodward Avenue.

> *One of the most practical novelties shown during the Automobile tournament will be the Auto-Sleigh....Mr. Lewis and his Auto-Sleigh are a familiar sight to Detroiters and can be seen on Woodward Avenue every day during sleighing season....The runners are practical, can be attached to any make of machine, and can be detached instantly. Mr. Lewis's car is a Waterless Knox.* Detroit Free Press, *February 8, 1903*

CHRISTMAS SHOPPING GETS DANGEROUS

The most immediate change for Christmas shoppers was the new danger of autos on the streets. On Christmas Day in 1919, twelve pedestrians were hit by autos on Detroit streets; one man died, and the other eleven were in serious condition. In 1915, on Christmas Eve nine people were hit by

autos. Children were especially vulnerable and their stories extremely tragic for families on the holidays. It wasn't until 1940 that police celebrated a "deathless holiday" with only two pedestrians injured that season. They attributed this to good driving, good weather and a targeted campaign by police to remind people to drive with care.

Early on, automobiles were considered something for the wealthy at Christmastime, to be driven around town by chauffeurs. Up until the auto appeared, Christmas was believed to be the time when rich and poor interacted, shopping together, but that changed.

A woman dressed in furs has a grievance, "The assortment of toys is so limited, everything is so common place, so cheap. Have they nothing that costs more?" A slip of a girl in a faded calico dress, coat that has come on down through the family without regard to fit or appearance, and shoes that are rundown at more places than the heel, gasps as the grand lady tosses aside a great doll whose trousseau represents more of an outlay than the girl is accustomed to having spent on her in a year. To her astonishment she hears judgment passed, "It's too cheap!" As my lady in furs tosses her head and sweeps on in search of something worthwhile, the girl timidly sidles up to the sales lady. "Have you got a doll for ten cents with real hair, and that shuts her eyes?" she asks anxiously. Five minutes later she disappears in the crowd, carefully carrying a bundle that will bring happiness to a younger sister. Her Christmas shopping is done, and her ten cents will bring more solid enjoyment to her and to the recipient of the gift, than will the dollars of the lady of the furs. Contentment doesn't always ride in automobiles. Detroit Free Press, December 13, 1908

As the price became more affordable, giving a new car for Christmas became popular; as early as 1906, automakers began taking orders for Christmas cars at auto shows across the country. By the 1920s, men were buying cars for their wives:

Indications are already observed by automobile dealers that the practice of giving motor cars for Christmas presents is likely to attain higher volumes than ever recorded before....R.S. Cole, Vice President in charge of sales for Huppmobile observed, "The two-car family is firmly established in this country as is evidenced by the fact that nearly every home now being built includes a two-car garage....Where the wife is to have her

own auto, it is becoming very common for the husband to make the gift at Christmas." Detroit Free Press, *November 25, 1928.*

In 1927, Nash Motors Company began a national advertising campaign to "Give a Nash for Christmas":

For this is "Give a Nash for Christmas" week, and we cordially urge you to come in either day or evening and see the display of new Nash models.

Nash is a wonderful car for winter driving. Safer. Much easier to manage. Quick to start. The motor is smoother and finer due to the Nash seven bearing principle. Finer coachwork keeps out cold drafts. Crankcase "breathers" prevent oil dilution and prevent fumes from entering the interior. Nash four-wheel brakes are safer because of two-way action.

Pick out your Nash today for delivery bright and early on Christmas morning. Twenty-four new Nash models to choose from priced from $875 to $1,990.

For those who couldn't afford to give a car for Christmas, there were useful auto accessories. In 1920, these suggestions in the newspaper included the following:

How about robes for those who drive open cars the winter through, especially welcomed by passengers in the backseats. Robes can serve double duty, as they can be draped over the radiator when the car is not moving to protect it. A stylish glass flower vase for the instrument board adds a touch of grace to the interior. Fur lined "hand coverings" [gloves?] are welcome along with the robes. For the practical man who drives, get him a set of fenders, a sensible gift. An automatic fire extinguisher always at the ready for going on tours of any length. A devise for greasing the car, an automatic grease gun is a welcome gift to avoid soiling one's hands to do a messy job. A new steering wheel equipped with a lock, or a lock for the entire automobile so when he parks, he can leave the car without fear of it being stolen.

Chapter 5

THE THANKSGIVING DAY PARADE
AND SEEING SANTA CLAUS

The parade was started by Hudson's after public-relations manager Albert B. Mills realized the success of Eaton's Department store in Toronto having sponsored a Santa Claus parade since 1905, the oldest in North America. In 1924, the Hudson's parade began. It was initially called the Michigan Thanksgiving Day Parade, and just under 100,000 people watched twenty-six floats based on children's nursery rhyme figures, pirates, "gypsies" and gnomes move up Woodward Avenue. Mother Goose, Old King Cole and Peter, Peter Pumpkin Eater were pulled by horse-drawn milk wagons and hay wagons with heavy iron wheels. Also included was a live elephant named Toto. Five high-stepping bands provided music and excitement.

The parade was first broadcast on radio station WWJ in 1931. First televised locally in 1948, today the parade is broadcast nationally to more than 100 million viewers. By 1946, crowds had reached 150,000, but things really took off in the 1950s when crowds reached half a million.

In the 1954 parade, 1,300 Hudson employees participated in the festivities. Myrtal Shannon portrayed the old woman on the Old Woman in the Shoe float. She waved to the crowds from the very top the towering shoe, wearing a bonnet and cape, very proud that she had participated in every parade from the beginning in 1924. Of course, she worked in the shoe department at Hudson's. She remembered the days when after a pair of shoes were purchased, a tea cart of polishes and shoelaces were wheeled out for the customer to consider buying like a fancy cart of desserts at a posh restaurant.

The thirty-third annual Thanksgiving Day Parade makes its way down Woodward Avenue in 1957. *Author's collection.*

The parade was the imaginative product of the Hudson's Display Department. Employees were assigned their tasks. One of the harder jobs requiring strong, muscular male employees was wearing one of the giant Italian paper mâché heads, which came in big, medium and small. They are the pride of the parade; they go over the carrier's head and rest on the shoulders. The medium heads stand nine feet in the air, while a big head reached thirteen feet high; on windy parade days, it was very difficult to keep your balance and stay steady. Carriers of the big heads received eight hours of pay at time and a half, while medium and small got six hours and four hours of pay at time and a half. This task was made even more difficult because you also had to wear a bulky costume, like a snowman suit. Staying on course was difficult because there was only a small hole for vision, which was inadequate. You could generally see who was in front of you and know you were probably going in the right direction, but many men wore hunting boots because what they couldn't see were fresh piles of manure that were commonly left by parade horses.

In 2015, it was estimated over one million people came to watch the parade. In 1990, the first giant balloon, a thirty-foot cartoon character, Chilly Willy, blew away when a strong gust of wind lifted it from the parade only

to drop it in Lake St. Clair, where it was saved that afternoon by the U.S. Coast Guard rescue team. It returned to the parade and is marched yearly by the Chilly Willy fan club. The parade to Hudson's continued until 1981, when costs were too much for Hudson's and the owners planned to close the downtown store. The Detroit Renaissance Foundation became the sponsor until 1983. Hosting the parade was taken over by a nonprofit organization called the Michigan Thanksgiving Parade Foundation and put on by the Parade Company with the help of hundreds of volunteers.

Of course, the ultimate purpose of the parade is to see Santa Claus, and even though the weather might by raining or more likely subfreezing, kids don't seem to mind. (The parade has never been canceled for weather. It was canceled in 1942 and 1943 due to material shortages produced during World War II. In 2020, it was "scaled back" but not canceled due to COVID.) The kids were described watching the parade in 1930:

> *By 9:00 o'clock he* [Santa] *arrived at Amsterdam Avenue and the parade began. All the way downtown the kids were gathered. They hopped and skipped waiting for his coming. Some of them sat on top of automobiles. Thousands of little ones were held up high by their mothers or fathers. Thousands of bigger ones sat or stood on the curbs. Some of them spilled out into the street and got themselves tangled up in the feet policemen but no one seemed to mind.*

These days it's stepladders and plank boards for viewing seats all along Woodward.

Santa sat on his throne on the float all the way downtown, waving to children until they reached Hudson's; then he climbed a special stairway for him on the Farmer Street entrance. It was here that he was given the keys to the city's toy land and spoke to the crowds, drowned out almost entirely by thousands of screaming children. He would then disappear into his snow castle.

By 1965, a large blue Plymouth had been designated pick up lost children and deposit them at the lost children's round-up camp, where nearly fifty children waited for their fathers or mothers to find them. Patricia Zardoronsky, a police officer, and Sargent William Woolen the Central Station Traffic Safety said children were being quickly picked up. Zardoronsky added, "The little ones are braver than the big ones. They're sure their fathers or mothers will come for them." Woolen soothed a mother who had lost an eight-year-old boy: "He'll show up. We sweep up everyone afterward. If a father lets go of his kids to light a cigarette, he may lose one."

SUBSTITUTE SANTA

What many people don't know is that there was a substitute Santa in the Thanksgiving Day Parade. Two Santas, fully dressed in red suits with bushy, white beards and hats, were driven by van to the start of the parade on Kirby at Woodward and the Santa float. One Santa would leave the van and climb up the float to his gold and silver sleigh throne, waving and ho-ho-ho-ing to the small crowd gathered at the start of the parade, while the substitute Santa, also in full suit and beard, discreetly slinked out of the van unnoticed and was escorted to the rear of the float, where a secret hatch was opened. He would climb in a special compartment to ride unseen under the float, sitting on a narrow wooden bench. As the float began to move down Woodward, he would watch the pavement beneath his feet going by and listen to the cheers of the crowds. A substitute was needed in case something happened to the Santa on top of the float. One time in Toronto, Santa collapsed from heart failure during the parade. To soften the trauma and ensure the parade went on, Hudson's had the secret sub-Santa at the ready.

In 1969, the substitute Santa was sixty-seven-year-old Henry Morris riding underneath; suddenly, the float stopped, and the compartment hatch was yanked open. He thought, "This is it. Big time for me," but that wasn't the case. There had been a bomb threat to the float, and a squad took twenty minutes searching carefully over the length of the float for a bomb. As they didn't find anything, the float proceeded on to Hudson's, where the real Santa climbed the marquee to receive the keys to the city and wave to cheering children. The police commandeered the float and sped off with Morris still inside. When they stopped at Hudson's Jefferson warehouse many blocks away, Morris climbed out.

He was asked if he was cold inside the compartment. "I might have been but the thought of a bomb on the float distracted me from worrying about it."

He had to walk a long way back to his dressing room at Hudson's, but smatterings of children leaving the now finished parade cheered him as he walked, which made him feel better.

SANTA CLAUS SCHOOLS

Before Santa was in Hudson's Toyland at Christmas, he was in front of Hudson's and also on Woodward at C.R. Mabley's Department store talking to children and cajoling parents to try to get them into the stores.

Girl visiting Santa Claus at
Kern's Department Store, 1940s
Author's collection.

Playing Santa early in the twentieth century was not seen as a professional job. Santas were everywhere, hocking newspapers, selling cigars, handing out flyers, many times in worn out or filthy Santa suits. They were referred to as "public Santas," and their behavior could be deplorable.

In New York City, one man named Charles W. Howard decided to do something about it. From 1948 to 1965, Charles Howard was the featured Santa Claus in the Macy's Thanksgiving Day Parade, perhaps the most visible Santa in the United States. He was a consultant to Edmund Gwenn, the actor who played Kris Kringle in the movie *Miracle on 34th Street*. Howard was appalled by the appearance and behavior of public Santas, so much so that he decided to open a Santa Claus School to train men on how to be a proper Santas and to teach women to be Mrs. Claus to enchant children and their parents. The first school was opened in Clinton, Iowa, but due to popularity Howard opened CWH Santa Claus Schools across the United States. In 1937, a Michigan school was established in Midland, and it has been training Santas and Mrs. Clauses for eighty-five years. It became a big business after World War II when the U.S. military sold thousands of surplus cameras and photography equipment, which gave birth to the idea of having your child's picture taken with Santa at the mall. The mall provides the setting for Santa while companies provide the Santa and a photographer. Companies like Kodak Camera Co. began sponsoring Santa schools. Some companies train and supply Santas to as many as two hundred malls, bringing some to complain about the commercialization of Santa Claus. There was a time long ago when fathers would don their Santa outfit on Christmas Eve, but with their tacky red suits and flimsy beards, they were no match for today's professional Santa.

Training in the beginning was casual and fun, but now, while still fun, it has become sophisticated, with video critiques and more. It begins with the basics, like making sure you have mouthwash and deodorant—you can't have Santa smelling like he just smoked a cigarette and drank a beer—how to keep your beard white (one man swore by bleach with Neutrogena

conditioner) and how to get toddlers to smile for the camera. One rule: never firmly commit to bringing a specific gift a child wants, even if a parent wants you to. And practice laughing from the belly, not the throat. However, sometimes training moves to other more complex issues. The Christmas after 9/11, when terrorists destroyed the World Trade Center in New York and attacked the Pentagon, Santa students began discussing tragedy and what they might say to a child who talks about the evil in the world killing innocent people.

"What do I say to a child who, when I ask what she wants for Christmas, says, 'I want my mom or dad back,'" was a discussion among the would-be Santas.

Tom Valent, who runs the CSW Santa Claus School in Midland, Michigan, with his wife, Holly, suggested an answer: "I'm really better at making toys. But when I go back to the North Pole I will talk to Mrs. Claus and we will say a prayer for you."

ON BEING SANTA AT DOWNTOWN HUDSON'S

My motto is, "I do not have the power to cure them but I do have the power to make them happy."
—*Greg Reaves, Hudson Santa for fifty years, head Hudson Santa in 1940*

Being a Santa Claus at Hudson's was the cream of the crop of Santa gigs, and the store hired only the best Santa's available. In 1970, Fred Husseman was a retired security guard at Macomb Community College, and for five weeks he hopped into his Volkswagen beetle and zipped downtown from his house on Harvard Street on the east side. He entered Hudson's and took the elevator to the Twelfth Floor, where he walked through a maze of narrow passageways that eventually ended at the "Santa Room," where Hudson's ten Santas gathered to drink coffee and eat donuts in various stages of their outfits. This was Husseman's fifth year playing Santa. He hardly needed to whiten his eyebrows, because his hair, parted down the middle, was nearly snow white, his cheeks were red and his sky-blue eyes were those of a younger man. He was actually described as a jolly person.

"You've got to like kids to do this job." He added, "Even so, we only work an hour at a time then break an hour. You have to be patient and not let anything show, like a headache." He told a reporter, "And forget the ho-ho-ho bit. It scares kids."

Husemann spoke the truth about patience, in 1970, 160,000 kids came to see Santa at downtown Hudson's from Thanksgiving to Christmas.

When a child comes to sit on my lap, I look them right in the eye and try to make them feel at home. Just draw them in gently and take both their hands especially if they are holding a candy cane or a sucker. They can get caught in your beard. I remember one little girl who came right in and put her arms around my neck and kissed me. She told me she had a record of me at home. Only then, did she tell me what she wanted for Christmas.

He added, "The little children believe in you. They are very sweet. They are in awe of you. Some of them are a little shy, but they love Santa Claus. And the ones who are getting older they will be no trouble. They will go along with you. It's an honor to be Santa."

In 1973, a twenty-five-year-old reporter posed as Santa Claus at Hudson's with coaching from Fred Husemann. A child sat on the reporter's lap, and when asked what he wanted, the boy answered, "I want a ginch worm."

"What's a ginch worm?" the reporter-Santa asked.

"That was a big mistake," Husemann told him. "Don't ask them what something is, if you don't know it. Just nod compliment them on their choice."

After years of playing Santa Claus, Husemann still looked forward to the season and felt a little sad when it ended. "Playing Santa is a privilege. I believe in it."

THE FIRST BLACK SANTA AT HUDSON'S

In 1970, Hudson's first Black Santa, Albert Fowler, didn't see many children, since Hudson's didn't tell anyone they had a Black Santa and would only direct children to him if the parent requested a Black Santa. That changed, and by the next year Fowler put in hours of work.

Albert Fowler was also a deacon at Greater Christ Baptist Church and a scoutmaster. He was originally from Albany, Georgia, and came to Detroit in 1942, where he made auto tires at U.S. Rubber until he retired in 1967. When he announced to his family and church that he was going to play Santa at Hudson's, it was big news; they were excited and happy for him.

"He was very congenial," his wife said. "He got beautiful reactions. The children would come to sit on his lap. They just loved him."

He was a big man at six foot two and slightly heavy and made an imposing Santa when he reached out to put a child on his lap. He played Santa from 1970 to 1975 and passed away in 1983.

After the downtown store closed, some organizations, such as the Booker T. Washington Business Association, gave Christmas parties for foster children in Detroit to see Santa in places like Pullums Place on Woodward Avenue.

Letters to Santa

· ·

Dear Santa Claus,
Please bring me a doll for Christmas, and I want you to bring me a nice
pair of gloves for Christmas. Please bring me a nice little cat on wheels
for Christmas, and I want you to bring me a nice picture book. I want a
nice little dog on wheels for Christmas, and I want you to get me a nice
little box for Christmas. And I want you to bring me a nice set of dishes
for Christmas and get me a nice little basket.
From Ella Jordan, age 5, 1893

Dear Santa,
For Christmas I wood like a doll and a doll high chaire and a pair of
skates one runner skates and a trunk and that's all but Santa I wood
like some nuts and candy and a orange and that's all and my sister wood
like a doll and buggy and nuts and candy and that's all and my brother
wood like a pear of skates and a bicycle and nuts and candy and that's
all. goodbye. Dear Santa and I am Ruth Neithoyse.
Ruth Neithoyse, 1905

Santa Claus North Pole
Dear Santa:
Please sen me anythin you have left. I hope you have a big doll and a
little doll for my little sister and a job for dady.
Maureen Mahoney
XXXXXXXXX, 1938
[When the post office master read this letter, he immediately sent
a man out to check on the family and hired the thirty-five-year-old
father for a job sorting mail for Christmas.]

Dear Santa,
I am a little girl, seven years old. I thought I would let you know that I will be satisfied with my old doll, you could bring a new doll to some other little girl. You have always been good to me and I thank you. Be sure to come see us at Christmas.
Lovingly,
Mary Turner

The North Pole, Icicle Palace
To Mary Turner:
My dear little Mary,
I received your dear little unselfish letter. I like to have my children think of other children and not be greedy and ask for a lot for themselves. I thank you for your invitation to visit you and I came to your house on Christmas Eve. Ha Ha! You know I did although you couldn't see me but I am around you all the time. They call me Santa, but my other name is love because I love all my children. Do you know that sometimes you can see figures in the eyes of people you look at? Well, look deep into your Papa's and Mamma's eyes and see if you can find me there.
I did not forget the other little girl.
Your old friend,
Santa, 1919

Dear Santa,
I want a puppy for my little brother because he has cancer. He is five. He is very good for the doctors and nurses. He likes puppies and would like to have one. He will be coming home soon. He is at the Hospital.
Pamela Tanguay
Age 10, 1960

Santa Claus North Pole
My Dear Santa Claus,
Five of us are from the asylum. We are at the Scarlet Fever House and will not be able to leav here before Christmas still we thought we'd let you know where we were for this is such a lonely place you might pass us by. So if you are not afraid of catching scarlet fever come this way and you will find our stockings all hung up waiting for you. We do not want very much this year because we could not take it back with us so dear Santa Claus you bring what ever you have left after you have bin to all little boys and girls.
Emma Albrecht
Age 7
Scarlet Fever House, Harper Hospital, 1892

Dear Santa,
I have left 25 cents of my money at your Free Press Agency. I hope everybody gives some so you'll have what you need to take care of the poor girls and boys of Detroit who are watching for you. And I hope Dan [a carrier pigeon] takes my letter to you and you can please feed him and let him fly back to Detroit.
With Love,
Elenore B., 1921

Dear Santa,
Here is my list of things I want
Racing Cycle $5.98
Magnetic dart board $3.95
Varsity basketball $3.95
Official size football $3.50
Hocus Pocus $8.95 (for tricks)
Bowling game $6.95
Wood tool set $12.95
Love, Gerald
XXXX
Gerald Craft, Age 8, 1973

Dear Santa,
I haven't had any Christmas tree in four years and I have broken my
trimmings [sic] and I want some roller skates and I want a book. I can't
think of anything else. I want you to think of something else.
Edsel Ford, age 8, 1901

To the Woodward Avenue Santa Claus
Dear Santa,
I thought I would write you a little letter about what I want for
Christmas. I want a big doll and a buggy and a pair of new shoes. And
some candy and nuts and a new ring. But a little ring for I am little. I
wish you would come early in the morning. I am ten years old but I am
very little. I will hang up my stocking Christmas night when I go to bed.
I wish you would bring me a pair of skates.
Your little friend,
Katie Kiehl
On Michigan Ave at Clippert Street, Springwells, 1898

Dear Santa Claus,

We never had a good Christmas yet. My mother needs some shoes, a
dress and some underwear and we would like to have some good to eat.
And I have no shoes or stockings.
Unsigned, 1914

Santa Answers

In 1986, Detroit mail carrier Joyce Williamson, age thirty-eight, underwent surgery, so she could handle only light physical work. The U.S. Post Office asked her in the autumn if she would be interested in answering children's letters to Santa. She was excited to take on the challenge, and letters began coming in by mid-October.

Working from her office on the eighth floor of the main post office on Fort Street in downtown Detroit with two full-time helpers, she enjoyed reading over five thousand letters from children—many included a picture. She used this Santa response:

Dear Little Friend,

Your letter made me glad that you were good. Soon I will be visiting all good little girls and boys. My elves and I are very busy day and night making dolls, toys and games to bring to your house on Christmas. My reindeer are rested and ready to go, so if you are awake and hear noises so slight, it's my reindeer and I when we stop on Christmas eve.
Merry Christmas to all and to all goodnight.

Of course, many children who write to Santa need more than a nice letter. Williamson said she saw many letters from children asking for things for other family members. Using the return address, mail carriers were notified and sent to check the home to see if help is needed.

"We have sponsors that adopt those families and those children and make it their responsibility to make sure those families have a good Christmas," she said. "Families don't usually turn down a helping hand."

All fifty departments in the ten-story Fort Street post office building sponsored at least one family. Williamson sent letters to post offices throughout southeastern Michigan reminding them to send children's letters to her office. "The post office really enjoys doing this program," Williamson told the *Detroit Free Press*, December 25, 1986.

Chapter 6

CHILDREN'S CHRISTMAS TOYS

Backward, turn backward, O Time, in your flight,
Make me a child again just for tonight!
—Elizabeth Akers Allen

As long as there have been children, they have had their toys. The oldest known doll toy is thought to be four thousand years old. In the early days of Detroit, then as now, the charm of Christmas came from children. The French children would set shoes by the fireplace, hoping small gifts would be left in them.

Early on, gifts were homemade; commercial presents from stores were a rarity, way too expensive for most families. Girls' dolls were handmade rag dolls, where dolls from stores were imported, usually from Europe. They were also considered too fragile for common kid's play, made of unglazed porcelain or wax. A girl's doll described in the *Detroit Free Press* in 1865 had "white satin robes, real shoes, genuine hair, a round face, snow white cheeks touched with spots of red, pinched up mouth and large blue eyes." In 1836, an eight-year-old girl, a blacksmith's daughter, received a wax doll with glass eyes and real hair, the only purchased doll she ever had. "One day," she wrote regretfully, "I went to look at it and it was ruined. The sun had shown in so hot that it had melted the wax to my great greef [*sic*]."

Dolls were so delicate that the Sears catalogue always offered various replacement parts, including heads and body parts. Many girls did not get new dolls every Christmas—the dolls disappeared only to reappear in a new dress or wig or even with a new head.

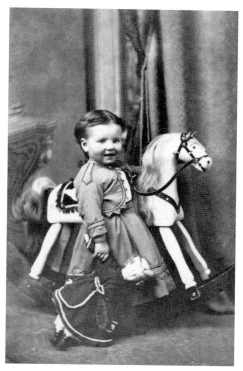

Left: Girl with her doll and a rocking horse in 1866. *Library of Congress*.

Below: Boy looking at toys in display window, 1910. *Wikipedia*.

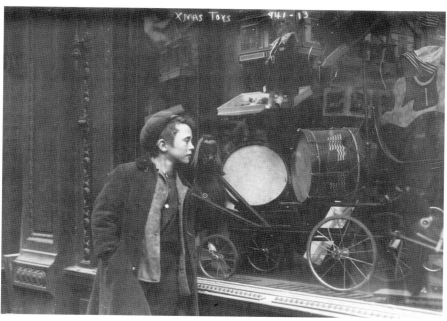

"I remember I got a note from Santa that they were going to take Bubbles," recalled one girl about the doll her aunts had given her shortly after 1900. "I must have carried Bubbles by the feet; I was short and her head was badly damaged. Santa Claus was going to fix her. They took her. I had a little playroom off the dining room and I can remember being very lonely without Bubbles."

By 1840, store-sold toys had become more common, at least for boys. They included wooden guns, sabers, rocking horses, whips, soldiers with gold helmets and toy horses with real manes. When not playing war or whipping their sisters, boys had marbles, balls and kites. Girls had dolls as well as kites, skates, hoops and balls. According to historian Steven Mintz in his book *Huck's Raft: A History of American Childhood*, toys were marketed to parents and meant for group play. Modern toys implied a solitariness that was not part of childhood before the twentieth century.

As Christmas became a commercial holiday, store-bought toys later in the nineteenth century were marketed to parents as a way to teach children adult values and skills. Toys for boys centered on science, technology transportation, construction and combat and hunting. They included train sets, chemistry kits and Crandell's building blocks, which appeared in 1867. (Lincoln Logs and Erector sets would come in the 1910s.) Toys for girls emphasized homemaking, child nurture and activities of domestic life, including tea sets, play kitchens, dollhouses and dolls, intended to socialize girls to become housewives and mothers.

By the 1890s, toys had become mechanically complex. American children wanted realistic toys—locomotives that actually puffed smoke and kitchenettes that had groceries that looked like the real thing only small.

The mechanical inventions in play things fairly puzzle and bewilder the salespeople who handle them....I stood dismayed before the steam engines with "power connections," electrical motors of all kinds, and mechanical toys which I had not the faintest idea how to manipulate them, nor what they did when started. "Why," said the young lady in charge. "I cannot keep up with it all. The boys come in and know much more than we do about our things. They explain our goods to us, and their scientific workings in surprising ways." Detroit Free Press, *1893*

While electric motors powered by batteries were new and popular, steam-driven toys were more numerous—steam-driven pile drivers, steam shovels,

steam locomotives. Other power-driven toys were called "clockworks" or "mechanicals," toys that were wound up and spring-driven. Examples were a French peasant doll that offered a cup of tea from a tray as a music box played "Girofle' Girofla"; a cobbler who cobbles a boot, looks around, winks and smiles; a bear strumming a harp; and many more hopping frogs, barking dogs, fluttering insects and chickens pecking the ground as they strolled about.

Then as now, the trouble was finding something new to give the kids. In 1906, the toy king of Detroit was Louis Rabaut. He expounded on this problem for the *Free Press*:

> *There's nothing quite so hard in all the world to get hold of as a new design for a toy. The toys come out in the early fall, and we know just what we'll have to offer, but with the approach of Christmas it's the same story— women and men rushing form place to place in quest of something different.*
> Detroit Free Press, *October 5, 1906*

TWENTIETH-CENTURY TOYS
MARKETED DIRECTLY AT KIDS

In the late 1920s, toys began being marketed directly to kids. Since kids were all listening to the same radio programs and later, television shows, something new emerged: the fad. In 1955, during the height of the Davy Crockett craze, ten million coonskin caps were sold. Three years later, two men, Arthur Melin and Richard Kerr, heard that Australian children were using bamboo hoops to do exercise. They made theirs of plastic, called it a Hula-Hoop and within four months sold twenty-five million of them.

One of the earliest toy fads was in the first decade of the twentieth century: teddy bears. Louis Rabaut explains:

> *Nothing ever caught on like the bear—just a simple bear made of thick, fuzzy plush in white, brown and black but the children have taken the big ungainly thing right to their hearts. Boys and girls, rich and poor, all in love with the bear. In Atlantic City you could see the youngsters by the hundreds toddling along or in autos or carriages hugging the cumbersome bears.*

Another famous example was in 1928, when an entrepreneur named Donald Duncan invented the parking meter and introduced through Good

Girls playing with hula hoops, 1958 *Library of Congress*.

Humor trucks ice cream bars on a stick. In 1927, he was in Santa Monaco, California, watching a Filipino busboy performing tricks for enthralled guests with a handmade wooden yo-yo. Duncan offered to buy him out and began the Duncan Yo-Yo company. From 1930s to the 1960s, he sent yo-yo demonstrators across the country dressed in white cardigan sweaters and performing eye-popping tricks with catchy names, like "Walk the Dog," "Rock the Baby" and "Around the World." He patented the name *yo-yo* in 1932 so competitors were forced to call their versions Return Tops and Whirl a Gigs; however, the legal expenses required to protect his patent and an overextended advertising budget forced Donald Duncan to declare bankruptcy in 1965.

TOYS GO PLASTIC

Prior to World War II, toys were commonly made of either metal, wood or cloth. Duncan yo-yos were made of hardwood such as maple, ash or beech or steel. They didn't make a plastic yo-yo until 1957. Other toys such as Easy Bake ovens were printed sheet metal, Tonka trucks were

stamped metal and girls' play kitchens were sheet metal and the pretend groceries cardboard.

By the late 1940s, Fisher Price, then a fledgling firm a bare ten years old, was the first company to make its entire product range in plastic. It was such an instant hit that rivals like Ideal began to copy it with the staggering sales achievement of over three million plastic telephones in just a few months. With plastic's bright colors and light weight, it caught on quickly with children. An added benefit for toy makers, plastic toys could be produced faster to meet enormous demand, much faster than manufacturing metal or wood toys. U.S. toy sales soared from $84 million in 1940 to $1.5 billion by 1960.

Hasbro would become *the* name in boys' toys, introducing the famed GI Joe on February 2, 1964, which would sell nearly ten million copies over the years. GI Joe came dressed in fatigues with accessories like helmets, packs and canteen, flamethrowers, grenades, M1 rifle, bazookas and a walkie-talkie (who came up with that name?). Eventually, he had thirty-three outfits to dress him up, including an astronaut suit, camouflage and spiffy dress blues. In three years, eight million GI Joes had been sold for $3.99. Also in 1967, a talking GI Joe was introduced. You would yank on his dog tags, and he would shout eight battlefield commands, like "Take the jeep and get some more ammo fast!" and "Medic, get that stretcher up here!" He had a scar on his face to man him up a bit and was completely moveable with twenty-two bendable joints. And most importantly, he was not a boy's doll. Please—GI Joe was an "action figure." In 1969, Joe was put on the reserve list as sales dropped at a time when showing toys in combat with rifles and grenades was not cool, man. But he was brought back to full glory in 1992, eleven and a half inches of pure fighting machine ready for active duty, Sir!

It was not until the end of the 1950s that the Barbie doll, the undisputed star, would appear on the market. By 1999, forty years on the market, her sales had topped the billion mark. In 1999, it was said that 95 percent of girls from age three to ten owned a Barbie; the average girl had eight dolls. Mattel, the maker of Barbie, stated that the doll generated $1.35 billion in sales in 2020, half of all Mattel's revenue in North America. She has been issued fifty-nine career outfits, including a police uniform with a ballroom dress for the policeman's ball. Today, more than one hundred dolls are sold every minute. Barbie is sold in 150 countries worldwide.

Did you know that Barbie has a back story? Her last name is Roberts. Her middle name is Millicent. Her parents are Margaret and George. She was born in the fictional town of Willow, Wisconsin. Her birthdate is March 9,

and since she was "born" on March 9, 1959, she is technically in her sixties. She goes to Willow High School, where she met her boyfriend—always an accessory—Ken Sean Carson.

Barbie has not been accepted by some adults, especially feminists, some educators and those concerned with racial stereotyping; they cited an infuriating example when a Barbie outfit of a female U.S. Marine uniform had Barbie with a hairbrush clipped to her belt instead of a gun. In 1993, the BLO (Barbie Liberation Organization), in its fight to bring attention to gender stereotypes, which they called "Operation Newspeak," sidetracked shipments of Barbies and Talking GI Joes and switched the voice clips in three to five hundred dolls and returned them to store shelves. On Christmas morning, when some child pulled Joe's dog tags, he said, "Math is hard," and the girls' Teen Talk Barbie barked orders like "Cover me, and I'll get that machine gun."

Chapter 7

CHRISTMAS CARDS

According to Hallmark Greeting Cards, Christmas is the largest card-sending holiday in the United States, with approximately 1.3 billion cards sent annually. Christmas cards began in the 1840s as a business compliment given to customers or suppliers. Englishman Henry Cole conceived the idea of Christmas cards in 1843. Too busy to write a personal holiday greeting, Cole hired well-known London artist John Calcott Horsley to design a card he could send to all his acquaintances. Christmas cards followed the same evolutionary path as other Christmas traditions: after the 1850s, they began expressing more sincerity, religious themes and childhood sentimental scenes. Until then, they could be bawdy and crudely humorous with fighting animals, murderous mice or dead birds, as in England, people considered Christmas a time of humor, good cheer, eating and drinking.

In 1848, Louis Prang, an exiled German revolutionary living in the United States, opened as a publisher in Boston. He printed cards modeled on British Christmas cards that offered more personal sentiments for the general public. His cards were printed using a lithographic process called chroma that produced clear, vivid colors. This was what began American's love of Christmas cards.

Across the nation, Christmas cards became a big deal in the latter part of the nineteenth century. In Detroit, some stores, like William Berry and Co. on Woodward or Thorndyke and Norse on Larned Street, devoted entire floors for an immense display of only Christmas cards.

A Hearty Christmas to you All!

"May good digestion wait on appetite"

Above: Humorous Christmas card from nineteenth century. *Author's collection*.

Opposite: Advertisement for Prang Christmas cards, 1886. *Author's collection*.

Card producers like Prang hired both men and women to illustrate cards with flowers, birds, angels, animals, childhood scenes and nativity scenes. The printed illustrations were then taken to women known as finishers and embellishers who pasted the cards onto satin padding or added silk fringe, tassels, hanging cords and other decorative touches popular during the Victorian age.

Prang's success led to a voracious need of more illustrators, so in 1880, the company began to hold national contests for the most beautiful Christmas cards. The cards were judged by a panel of artists and a separate group of retailers. Prize money was $1,000 for first prize down to $200 for fourth prize. Many times, winners also were awarded commissions for more illustrations in future years. In the first two years, thousands of cards were entered from across the country, which overwhelmed the event. Later, Prang restricted entries to twenty-two illustrations, which were put

on display at art museums in Boston and New York for the general public to see. The winner of that competition received the "popular" prize, and their artwork was produced as a card along with the "artistic" award winners (as determined by the panel of experts).

In 1881, the famous Symbolist painter from New York City, Elihu Vedder, won first place for the Prang contest. The Committee of Awards for the Prang Christmas Card competition were famous painters and designers: John La Farge, Louis C. Tiffany and Samuel Colman. The *New York Post* wrote after the announcement of the winner, "It's easy enough to see that art is advancing in this country when Elihu Vedder makes our Christmas cards." (Elihu Vedder was an American-born Romantic painter and illustrator whose reputation is based primarily on paintings derived from dreams and fantasies. In 1884, he illustrated an edition of *The Rubáiyát of Omar Khayyám*, which is considered his finest work.)

Illustrators like Rosina Emmet (who won first prize in 1880) and Dora Wheeler (Emmet's friend, who won second prize in 1881) gained national fame for contest-winning Christmas cards. Wheeler's winning card showed whirling cherubs in pearl white with pale pink blossoms on the borders, surrounding a stanza from Joaquin Miller:

> *Peace on Earth*
> *We bring thee peace, the savior saith,*
> *The white unfolded wings of faith,*
> *Bring balm, myrrh and incense sweet*
> *The light to guide they weary feet*
> *The love, the hope, the tranquil bliss,*
> *The blessed Christmas promises.*

Other female winners included Anne Goddard Morse, who won fourth prize in 1880 for her design of children with holly branches, and Florence Taber, who placed fourth in 1882 for a design of children gathering holly in a snowstorm. These events were considered the only venue in the art world that offered women an equal chance at success as men. Prang used an equal number of men and women as card illustrators.

In Detroit, the Prang winning cards were put on display at the Art Book Store owned by D.P. Work in 1882. Other cards were also displayed. Hand-painted cards were sold at D.P. Work's store for $7 ($188 in today's currency value). The Victorian tastes were not limited to peace on earth and religious sentiment. Humorous cards were also popular, like this series of cards that were displayed at Work's bookstore:

> *The artist is a young lady from New York. She has found nothing too quaint,*
> *grotesque or pretty to depict. Small black cards, appropriately inscribed*

show Mr. and Mrs. Frog and the whole family of little frogs attired in most bewitching costumes going to choose a Christmas tree. Detroit Free Press, *November 22, 1882*

Japanese-inspired cards were also shown, one of which featured a leafless twig with two tiny feathered owls sitting at the end. Below, a banner read, "Merrie Christmas," in gold lettering.

In the later nineteenth century, people gave not only Christmas cards but also Christmas booklets, like this one described in 1883:

One of the very choice series of illustrated holiday booklets with fringed edges, the cover with gold and pale blue, with flowers and bird in natural colors with one leaf, and a gold flowered wreathed nest, with eggs on the back. The poem is given on the first inside leaf and with the facsimile of the author's handwriting, with dainty flower and bird illustrations on every page. It is designed for a Christmas card or gift booklet for the holiday season. Detroit Free Press, *December 8, 1883*

However, even artistically beautiful cards could grow stale, and Prang's cards were expensive. By the mid-1890s, American firms had begun importing cheaper cards from Austria and Germany, and Prang decided to quit the Christmas card market.

When Prang quit producing Christmas cards in the mid-1890s, it began the dark days for Christmas cards. Likewise, in the 1890s, the British slowed buying English-made Christmas cards, and the custom of sending Christmas cards was dying. It was as if the disinterested public wanted to get away from the Victorian-style cards. According to industry historians, 1890 to 1906 was the break from the old style of Christmas card. They were still being published but were cheap and imported versions of the Prang-style cards. A new generation of American publishers began to return to cards of quality. The modern card also had novelties, such as a card sent in 1910 had six letters in envelopes inside labeled "Read at Bedtime." The sentiment inside read:

There's six Christmas letters awaiting you here
To bring you my wishes for glad Christmas cheer,
And if the directions you duly obey,
I'll greet you by proxy through six times a day.

Prang Christmas card from 1885. *Author's collection.*

Giant oversized Christmas cards were sent: "I'm so very, very weary of the tiny Christmas cards" was printed in the card. One company sent calendars in cardboard tubes with the Christmas sentiment printed on the tube. Another company included in the card a small, wafer-thin but playable phonograph record of a rich baritone singing the card's sentiment to the turn of "Auld Lang Syne." Thousands of Americans received the card and the music as if Santa himself were singing to them.

During Prohibition, many humorous Christmas cards made fun of no drinking. One card had a donkey with a small string of hemp attached, which read:

Old Gray Mare Barometer
If the tail hangs to the right, summer is over,
To the left, winter is over,
If the tail falls off, Prohibition is over.
N.B. Don't pull it off. It won't work

Not a single mention of Christmas.

Special title cards became popular—for example, "Merry Christmas, Mother." Mother cards were always the most popular, followed by wife and father. Sweetheart cards were also popular. It should be noted, to add insult to injury, men paid a lot more for sweetheart cards than for wife cards.

As Detroit's automotive industry bloomed in the early twentieth century, cards featured Santa delivering gifts in a new green Hudson, Packard or a Ford. Custom cards for businesses were common in the automotive industry and throughout the United States. One commercial fishing company in Gloucester, Massachusetts, sent Christmas cards printed on actual dried cod skin.

Love of Christmas cards began to return into the twentieth century, and by the 1920s the post office in Detroit reported they were handling two and a half million Christmas cards every day, in addition to thirty thousand small parcels and twenty thousand large parcels.

In the early 2000s, Americans mailed about two billion Christmas cards annually, according to data provided to MarketWatch by Hallmark Greeting Card Co., but by 2015, those numbers had plummeted to 1.18 billion. The vast majority of Christmas cards are sent by people over fifty years old; however, there has been an uptick in cards purchased due to millennials' rediscovery of snail mail and the joy and personal expression of exchanging Christmas cards (and handwriting probably). Holiday card sales were up

Midcentury Christmas card with automobile. *Author's collection.*

14 percent from 2019 to 2021. What millennials do not seem interested in are the box of Christmas cards with generic Christmas symbols Americans traditionally signed and sent each year. The chief marketing officer at Hallmark has said that millennials are looking for special cards for important people in their lives. They prefer to select something personal, not just a generic holiday image they buy by the box, sign and send out.

CARD ETIQUETTE

In past years, before email, texting and the like, many people sent out and received hundreds of Christmas cards, which, once received, were displayed on a counter or in a cloth banner with large pockets, hung on the wall. In 1941, one Detroit newspaper columnist, Katherine Brush, had her doubts about the value of such activity. She noted, "As a battle-scarred veteran of many Christmases I have made a study of this greeting card situation." One year, she had 300 cards embossed with "Mr. and Mrs. So and so," but there was a mistake on the plate and the embosser never noticed that the cards read "Mr. and MR. So and so." Brush didn't notice it when she sent them out, and "Did any of the 290 odd recipients of the Mister and Mister cards notice it? Two hundred and ninety times-no," making her ask if anybody even opened the envelopes, let alone read the cards. She noted that these were not cheap cards but the big stiff cards, "50-centers, not a penny less."

Another consideration she pointed out was when do you mail the cards?

There is no proper day or date for mailing out your Christmas cards and no matter when you do, it will be wrong. For if you mail your greetings late with the hope of getting them there on Christmas Day, (1) you're burdening the post office, and (2) giving the recipients the impression that you only remembered to address a card to them after THEIR card came to you. Whereas if you mail your card early it's just the reverse, as everyone knows. In that case you will never be sure whether the influx of greetings that you yourself receive at the last minute, are truly affectionate or dutifully reciprocal.

On the other side of the exchange, cards received tended to fall into a pattern. The columnist noted that the first card received was usually a small brownish card with an acorn and sprinkled with mica. The next card was from Liz and Bozzie, someone you don't even remember. Then a gaudy cheap card from the owner of a bar and grill you go to. If you were an apartment dweller, you received a card with no stamp asking for a contribution of so much from each apartment for the building's employees. (My own earliest email Christmas greeting is from the sales guy at the Chevy dealership wishing me a Happy Holiday and reminding me when my lease is up. Thoughtfully, he also sends me a birthday email every year.) Then for the columnist, "the cards come in bunches, the big 50-centers, the little gay waggish ones that bachelors send, the photographic ones of people's doorways or their dogs, and the announcements of offspring." *Detroit Free Press*, December 8, 1941

Chapter 8

VICTORIAN CHRISTMAS BALLS
AND HOTEL DINNERS

Detroiters have always loved to dance. They were good dancers. The greatest dance teacher in Detroit was Herman Strasburg, who started the Strasburg School of Dancing in 1854. His son Herman Jr. took over the business in 1881, and his grandson Paul joined the faculty in 1914. They taught several generations of elite Detroiters, not only dancing, or as they called it the "terpsichorean art," but also "where all the graces and manners of the ballroom are imparted." Herman Strasburg said this about Detroit dancing:

> *Detroit is a great dancing town. More dancing is done in Detroit in proportion to its population than any other city in the United States. What is more, people here dance well and gracefully; there is less toleration here of freak dancing and that grotesque hopping and rushing and twirling which often makes a hit with the younger set. The early French inhabitants of this town were great dancers: and with them it was a real social art and that accounts for the popularity of the amusement here. You will find more men and women of an older generation dancing here than in almost any other place.* Detroit Free Press *September 15, 1906*

Dancing season started in winter. In the early days, there were no dance halls, and while some wealthy held balls at their homes, the lonely young men formed groups and gave themselves names such as the Alert Social Club or the Coreopsis Club. They would rent a small hall; print invitations;

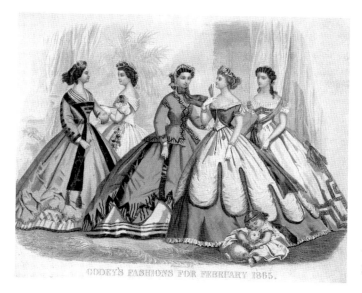

GODEY'S FASHIONS FOR FEBRUARY 1865.

Victorian ball gowns from 1865. *Wikipedia*.

hire an orchestra, such as Finney's Orchestra or Tinnette's Orchestra, for bigger affairs Schremser's Orchestra; and anxiously send invitations out to young women's and men's groups hoping they would have enough people attending to cover the expense of the hall, orchestra and invitations.

Once a woman accepted an invitation, she was given a card with a colored tassel and an attached pencil so prospective partners could write down their name opposite the dance they selected. The women always had a companion, and it was the duty of her young man to make sure she had partners for each dance, of which there were typically twenty. When interested in her, he wrote his own name down for three or four dances.

No dancing started until 11:00 p.m., and there was usually an intermission in which dinner was served. In the small dances, it was catered and had oysters on the half shell, chicken salad, sandwiches, cake, ice cream and coffee.

Dancing then resumed and went on till 2:00 a.m., when the orchestra played "Home Sweet Home" and the lights were turned up.

The biggest ball of the year was the Christmas Ball, which was usually held at Strasburg's Academy on Adams Street. At the turn of the twentieth century, it was held at the new academy on Sproat Street near what is now Little Caesars arena. It had seven thousand square feet of dance floor with balconies overlooking the action for those who chose to watch. The ball was held to sponsor the Women's Hospital and Infants Ward. The first Christmas ball began in 1893.

In 1910, the *Detroit Free Press* described the decorations: "The Hall was hung with Christmas trees lavishly dressed with tinsel ropes, electric candles, and shining balls. The trees connected to the gallery rails above the balcony boxes were festooned with laurel and studded with poinsettias. Green, white and crimson tulle completed a seasonal and attractive scheme of decoration."

The Christmas Ball for the Women's Hospital began in the early 1890s and was for the elite, the very wealthy, so the attendees spared nothing. Their dresses, including bustles and many other accoutrements they were required to wear or carry, cost in the thousands of dollars in today's money value. Many women ordered their gowns from Paris, which took six weeks to get to Detroit from France. Newspaper columns described the ball briefly, followed by multiple columns listing women and what they were wearing:

> *At midnight when festivities were at their heights, the swaying dancers, the soft strains of music and the varied colored lights, presented a dazzling scene....*
>
> *Mrs. H.B. Joy's gown was a gorgeous Parisian creation of turquoise blue, embroidered net over silver tissue. The bodice was elaborately trimmed in silver roses.*
>
> *Mrs. W.P. Manton wore a Paris gown of black spangled net.*
>
> *Miss Isabelle Bradbeer, an Irish crocheted gown trimmed in pink silk rosebuds.*
>
> *Countess Matchuska—light blue chiffon satin and white lace*
>
> *The richness of the gowns, the beauty of the women, and the presence of so unusually large a gathering of Detroit's most exclusive society all contributed to distinguish the Christmas ball.*

But on the dance floor, not all was heavenly for the women. Strasburg related:

> *Many men clasp their partners so tightly that it is a positive discomfort to dance with them. Most of them assume this position through ignorance, they imagine it's the only way they can give a girl proper support, whereas the fact is they make dancing a labor instead of a pleasure. You'll find these girls are not eager for these men's names on their programs. They are getting ashamed of being hugged around a ball instead of led.*

One could always take a break down in the supper room at midnight:

> *Quaint candlesticks with their scarlet shaded candles and holly wreaths with scarlet satin streamers spelled Christmas cheer to the merry dancers who flocked down in groups as the evening wore on.*
>
> *Amid all this warmth of Christmas color the hundreds of dancers moved, the shimmer of costly silks and the glitter of jewels heightened by the deep color of the decorations....But the happiest feature of last nights many sided success was the fact that the coffers of the Women's hospital and infants home were splendidly enriched.* Detroit Free Press, December 23, 1905

Cobweb Parties

On a more common footing were Christmas cobweb parties. These were popular in the late 1800s and early twentieth century up to the 1930s. A host would invite as many as fifty people to his or her house, tie various colors of yarn or cloth strips from a central location, such as the dining room, then run the strings through the house, around table legs, upstairs to the attic, out windows, crisscross with other strings, or to the darkness of the basement. A small Christmas gift would be found at the end of the line. Supposedly, this was a capital way to meet new friends or romantic prospects, as one was bumping into them regularly through the whole ordeal.

Hotel Christmas Dinners

Later in the Gilded Age, Detroit hotels competed for locals' business, and it became a custom for Detroiters to spend holiday dinners at hotel restaurants. It might be the Russell House, the Hotel Cadillac, the Ste. Claire, the Metropol, The Griswold House, the Michigan Exchange or another. The dinners included elaborate menus that guests took home as souvenirs. Guests also were entertained with waltzes, galops, polkas and medleys with live music from the house orchestra, set up in the dining room. These were four-hour dining experiences.

The following is the bill of fare from the famed Hotel Cadillac in 1888. (My favorite entry is the possum served with fried bananas.)

Blue points
Green Turtle a la Anglaise Crème *Custard au Consume*
Boiled Red Snapper a la Bolognaise *Fried Pampano, Sauce Tartar*
Potatoes Colbert
Celery Radishes

Boiled Partridge with Puree of Celery
Fresh Beef Tongue, Sauce Piquante Fowl, Egg Sauce
Prime Beef au Jus Hen Turkey with Oyster Dressing
Young Pig, Cranberry Sauce Loin of Lamb
Reed Birds, en Canape a la Chasseur Young Onions
Frog Legs on Toast Sauce Bearnaise
Terrapin Stew en cases, Maryland style
Squab with Chestnuts, a la Crapaudine
Sliced Cucumber Omelette Celestine Delmonico

Kirsche Wasser Punch
Green Olives

Prairie Chicken, sauce natural New Jersey Bear, apple jelly
Quail stuffed with Mushrooms Opossum with fried bananas

Chicken en aspic Fresh Lobster Game Salad
Boneless Turkey, Lettuce and Eggs

Baked Sweet Potatoes, Mashed and Baked Potatoes
Sifted Peas, Golden Beans, Stewed Tomatoes, Sugar Corn,
Asparagus Spinach Cauliflower

Christmas Plum Pudding with Brandy Sauce
Sliced Apple Pie Homemade Mince Pie
Lemon Meringue Pie Chocolate Eclairs Shavings Angel Food
Meringues with Cream Fruit Cake. Kisses.
Macaroons Lady Fingers

Nesselrode Ice Cream
Mexican Oranges Pomegranates Persimmons
Bananas Apples Malaga Grapes Pears
Mixed nuts Layer Raisons Figs Dates
Confections Orange Jelly

Hard Crackers
Edam Swiss Pineapple Roquefort Neufchatel Fromages
Café Noir Champagne Cider

Christmas Memories

ELNORA SIPP

I was born in Tampa, Florida. I am the fifth of seven children. In December in Tampa, it was still warm, and we roller-skated up and down the sidewalks and played outside games. We did not wear coats, but we wore rain jackets. In Florida, it rained a lot in December.

I was almost one month away from turning five years old when my parents packed us up and moved us to Detroit. We parked in the driveway of our new house on Madison between Lafayette and East Vernor. My mother told us to stay in the car; my father said our mother should see the inside of the house first and alone. We waited and didn't know what the white stuff was on the streets and sidewalks, but it was cold and we were shivering. They finally returned, and soon after, my mother took us downtown to Hudson's to get our first winter clothes, coats and boots.

Downtown there was music in the air: bands were playing, choirs and high school choruses were singing. People standing nearby were singing along with them. Tall trees were lit with lights, vendors were handing out cups of cocoa and apples. It was a very happy time for me. As I was growing up, we went to free concerts at Ford Auditorium, where there was a Santa passing out candy and sometimes small toys to children.

When I became an adult, I moved out of Detroit and started teaching. Recently, my husband and I took our grandchildren, who live in South Carolina, to Campus Martius to go ice skating. My husband and I are not skaters, but they're really very good. But I was stunned by how beautiful it is there watching them gliding by on the ice rink surrounded by the tall buildings of downtown, the giant Christmas tree lit up, music playing and all the white lights twinkling from other trees. It is more beautiful than I remember it was as a kid.

Chapter 9

CHRISTMAS CHARITY

By the late nineteenth century, Detroiters were serving thousands of adults and children at Christmastime. In 1881, over six thousand Christmas dinners were served. Christmas dinner for two thousand people was served in Cadillac Square in 1899. Campfire Girls provided dinner and gifts for two hundred children under eight years old in 1921. Even men at the Detroit House of Corrections, Wayne County Jail and two hundred men at the McGregor Mission on Brush Street received Christmas dinners in 1902.

For the really massive undertakings, such as dinners for three thousand, tickets were given to the churches, which then gave them to individuals and families to make sure the people who ate were *truly* deserving. People were very poor. In some years, three tons of coal were handed out in small amounts to go along with dinner gift baskets so people had a way to cook their dinners once they got them home. Shoes, stocking and underwear were regularly given out along with toys to children. In 1901, the destitute could be found in Japanese Village, which was a collection of shanties on Orleans Street at Monroe. Another larger slum on Napoleon Street was called Tin Can Alley.

Kindness was also common in Detroit at Christmas. Women's clubs, churches and civic leagues began campaigns to promote early shopping to not just avoid the Christmas rush or get discounts but to "lift the burden of weariness" and relieve "the clerks, the cash boys and girls, the delivery men and the delivery horses at this busiest time of the season."

Forgotten, a 1914 drawing by Burt Thomas from the *Detroit News* and used by the Goodfellows from their very beginning. *Wikipedia.*

Newspapers and national magazines in the late nineteenth century were replete with stories of simple acts of kindness, albeit a bit maudlin, especially if their involved children or elderly. Here is a headline from Detroit in 1909: "Stooped Little Woman in Black Carries Dead Child's Gifts Back to Store. There Being No One Else at Home to Use Them."

THE GOODFELLOWS, MORE THAN 100 YEARS OF CHARITY

In Detroit there are 1,909 poor children who have nothing but their faith in the fairy story we have taught them. Detroit News, *December 19, 1914*

The Old Newsboys' Goodfellows Fund was started in 1914 by James J. Brady with the sole mission of bringing Christmas to poor children. Brady, along with about fifty Detroit businessmen, all of whom were former newsboys, sold newspapers on street corners to raise money to purchase gifts for kids. They are still going at it today. By Christmas 1922, the Goodfellows were serving over seventeen thousand children with food, baseballs, dolls, infant nursery needs, gloves, mittens and more. Combined with charity for adults, the Goodfellows helped thirty-five thousand people that year. Today, the

Women with award-winning dolls decorated for the Goodfellows in 1956. *Author's collection.*

Goodfellows serve six southeast Michigan communities and provide thirty thousand gift boxes that include toys, clothing.

James Brady was born in Corktown in 1878, one of eleven children all living in a simple wood-frame cottage. When he was still young, his mother died. His father, who owned a small corner grocery, managed to support his

family alone on the meager income of that store. James Brady began as a delivery boy at the grocery store, then shined shoes and became a delivery boy for Western Union. A bit older, he began selling newspapers at the corner of Fort and Griswold Streets. As he became an adult, Brady made a change and worked for a year on a western ranch as a cowboy. But he returned to Detroit and took a job with R.E. Olds factory, where he soon proved his worth and joined management. With others, Brady formed an automobile company, which was later bought out, so he started a bank. Eventually, Brady was appointed by the president of the United States to be the federal collector of the Internal Revenue Service for the city of Detroit. James Brady was well known and respected by many, and in 1914, he got the idea to gather the old newsboys, many of whom were also successful businessmen and friends of Brady's. They met in Brady's office, and he explained that each man would go to his old street corner and hawk newspapers for above the regular price, raising money to buy gifts and food for needy children. The men eagerly agreed; many grew up with very little and knew what it felt like to have nothing for Christmas. The *Detroit News Tribune* supported the group, running stories on the newsboys. On December 13, 1914, a headline announced, "Old Newsboys to Sell Newspapers on Streets for Benefit of Young Ones."

Their hope was to raise $400. Brady withdrew $400 from his personal bank account to cover that amount in case they didn't reach their goal. The effort was a success, raising over $2,000, and the tradition began. James Brady's son joined the cause, and to this day there are members of the Goodfellows who are Brady descendants. Sadly, Brady died of heart failure in 1925. A newspaper commemorated his passing:

> *Mr. Brady himself once a ragged newsboy, in his manhood a prosperous business man and banker, who remembered the poverty of his youth only to be stimulated into giving a helping hand to those who needed it most—the children of the poor.* Detroit News, *June 17, 1925*

Friends of Brady and those who admired him raised over $7,000 (over $110,000 in today's dollars) for a monument that was dedicated on June 23, 1928, to his memory. It is located on Belle Isle at Central and Inselruhe Avenues. The monument was designed by Samuel A. Cashwan (sculptor) and Fred O'Dell (architect). Inscribed on base is "James J. Brady, Old Newsboys Goodfellow Fund." On the left, a bronze plaque reads: "Because he loved the children of the poor and devoted his life to good works, his friends have caused this monument to be created and erected."

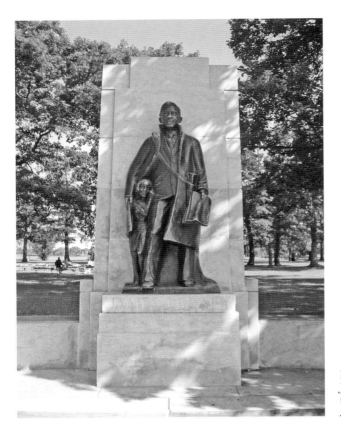

Belle Isle memorial to
James Brady, founder of
the Goodfellows, 1928.
Author's image.

On the right plaque: "This monument is affectionately dedicated to the memory of the late James J. Brady, founder of the Old Newsboys Goodfellow fund."

The monument was presented by his daughter Evelyn, who was then seven years old. Mayor John C. Lodge accepted it on behalf of the city. Members of the Common Council and Recorders Court, police and fire departments were in attendance, and seats for ten thousand people were provided.

THE SALVATION ARMY

The Salvation Army started in Britain in the 1860s and came to the United States a few years after that. The organization's start was rough, with established religion scorning and mocking members.

The Salvation Army from London is making a mockery of religion in New York, though these "Captains" and "Lieutenants" seem sincere enough. We do not object to ignorant advocates for Christ in their proper place; but it is no part of our religion to give prominence to ignorance....It requires only a little force of character and conscious industry to [read] and learn the alphabet, and people who are lazy and slovenly that they will not master this small lesson of the alphabet are too lazy to be voices for religion. The Methodist, April 2, 1880

The Salvation Army of uniformed men and women were likewise despised and sometimes violently attacked in Detroit and other cities across the country by drunken hoodlums.

The Salvation Army last night engaged in a pitched battle which raged for a long time and was only ended by the police drawing clubs and revolvers charging the gang of hoodlums who caused the revolt. A crowd of rebellious rowdies and a free fight emerged. Captain Weaver suffered

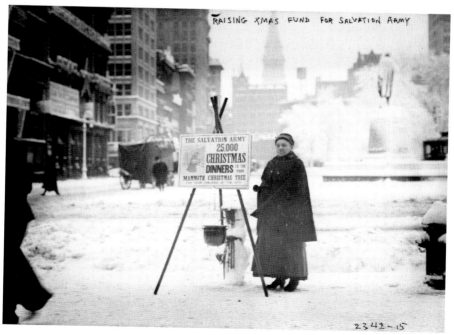

A woman dressed in her Salvation Army uniform raising Christmas donations on a cold day. *Library of Congress.*

the most, his uniform being torn off, his optics discolored. Undaunted he gave the battle cry of "Halleluiah!" and his co-workers joined in the melee until the arrival of the police. An assault on the barracks front and read with a fusillade of stones. The female members of the army screamed in terror as they saw the enraged ruffians closing in on them. The timely arrival of police saved them from further harm. Detroit Free Press, *December 15, 1883*

By the 1890s, the Salvation Army's resolute persistence began to pay off, and the resistance to them eased. Tributes from newspapers, churches and civic leaders began showing they were earning the respect of the American public for their sincerity in working with the poor around the globe.

It was less that twenty years ago that the Salvation Army consisted of a bunch of religious fanatics here and there whose principal business seemed to be to amuse a godless world and stir the contempt of the godly ones. Detroit Evening News, *1896*

The Salvation Army began hosting massive Christmas dinners in major cities, including in 1895 in Detroit, where they fed one thousand people in a single day. The event was run by a Captain Gifford, who addressed the *Free Press*:

Of course, some people may be a little backwards as they think our intention is to feed bums and lazy characters, but this is the farthest from our idea. Army members are out investigating everyday and securing the names of deserving families. Detroit Free Press, *December 25, 1895*

By the 1930s, the Salvation Army was distributing thousands of gift baskets.

By late Christmas morning volunteers of the Salvation army were distributing baskets of food to nearly 3,000 families. Each basket contained canned goods, chicken or meat and fruit. Detroit Free Press, *December 26, 1939*

During one Christmas in the midst of World War II, one thousand people were fed turkey dinners downtown, a Christmas party for two hundred children was given and volunteers visited destitute families in their homes

Giant Salvation Army red kettle of lights in downtown Detroit. *Author's image.*

with over one thousand food gift baskets. And on it went, decade after decade, for over one hundred years.

The Salvation Army has had help over the years from a variety of sources. Perhaps the most visible has been the Detroit Red Wings, through their

charity Hockeytown Cares. Starting in 2005, players as well as coaches and former general manager Ken Holland would join Salvation Army Red Kettle bell ringers throughout metro Detroit at Christmastime to compete for raising the most money.

In the late 1960s and for several decades after, an informal though significant fundraiser was held at London Chop House in downtown Detroit for the Salvation Army. Detroit's movers and shakers, including Max Fisher, Joseph L. Hudson, Ross Corbit of McCloth Steel and, for several years, Mayor Coleman Young, passed the hat at the Chop House during a Christmas Eve luncheon as the Salvation Army band played.

> *It was a remarkable scene. While mini-skirted hostesses escorted guests to their tables, primly uniformed Salvation Army ladies played coronet to "Hark the Herald Angels Sing" and "O Come All Ye Faithful" backed up in brass by the blue coated gentlemen of the band.*
>
> *Clinking glassware and jingling silverware made a very Christmasy counterpoint.* Detroit Free Press, *December 24, 1968*

The London Chop House fundraisers provided Christmas dinners for U.S. soldiers in Vietnam, toys to needy families and visits and gifts to people in rest homes and hospitals.

Today at Christmastime, Salvation Army volunteers can be found just about everywhere. The Salvation Army's Red Kettle Campaign is its most significant fundraiser. The Red Kettle Campaign brings its iconic red kettles to storefronts throughout metro Detroit during the holidays and raises funds to ensure it can provide much more than food and shelter to neighbors in need throughout the coming year. Funds raised at Red Kettle sites, as well as online and via mail, stay in the community in which the donations are made.

To promote the campaign, downtown Detroit features the largest red kettle in the world during the holidays.

CHRISTMAS CHARITY IN PARADISE VALLEY

From 1920 to 1960, the segregated Black neighborhoods in Detroit were Black Bottom and Paradise Valley. Black Bottom, which ran from the Detroit River to Gratiot and east of Brush, was a residential neighborhood, while the commercial neighborhood, Paradise Valley, was directly north and ran

from Gratiot north to Grand Boulevard. While overcrowded and deeply poor, Paradise Valley had some of the liveliest nightlife in the United States, with nightclubs, restaurants, dance halls, hotels and theaters that attracted leading Black musicians and performers from across the country, such as Sarah Vaughn, Duke Ellington, Dizzy Gillespie and many more.

But Paradise Valley came together in a big way for kids at Christmas. Many in Paradise Valley felt they were on their own even during Christmas. In the early 1930s, charities such as the Salvation Army were accused of refusing charity baskets to people based on race. In 1933, three Black women were refused baskets after applying, on which the *Detroit Tribune* of December 9, 1933, reported: "When the three women applied at [Salvation Army] headquarters, they were told 'We do not give baskets to colored people.'"

People had to have something for Christmas. In 1935, Joe Louis Booster's Club gave a Christmas fund show at the YMCA to a large crowd.

> *The show was superb and featured a galaxy of radio and stage stars together with outstanding talent, all of whom contributed their services gratis.... The proceeds from the show provided funds for 175 Christmas bushel baskets of food for the poor, also clothing for 55 persons and toys for over 100 children.* Detroit Tribune, *December 20, 1935.*

Paradise Valley had unofficial mayors who were elected through a poll run in the *Detroit Tribune* every two years in which readers made their choice. One of the first winners in the 1930s was Sunnie Wilson, the great promoter for jazz clubs and boxers and a friend of the boxing great Joe Louis. Sunnie Wilson described his duties as mayor, from his book *Toast of the Town*:

> *As Mayor of the Valley I met with politicians to seek ways to improve the conditions of the black community. We worked to educate and register blacks to vote. I visited community centers and handed out goodwill baskets to the poor black folks.... I became mayor strictly to help out my fellow black folks in Paradise Valley.*

Over the years, Sunnie Wilson owned or managed many clubs in Paradise Valley, downtown Detroit, and even Idlewild, Michigan, north of Grand Rapids, a Black vacation getaway. In 1941, he owned the enormous Forest Club at Forest and Hasting, which, along with a dance floor that could

accommodate seven hundred dancers and big jazz bands, offered a bowling alley—the Bowl-O-Drome—a roller rink and Sunnie Wilson's Cocktail Lounge and Bar with the "longest bar in the world" at 107 feet. Wilson claimed the Forest Club was bigger than Madison Square Garden.

At Christmastime, Wilson donated the roller rink to youngsters:

> *For more than 1,000 Detroiters from less than 4 years old to 14 years, the Christmas holidays weren't complete until Monday afternoon—when the congenial Mr. Wilson and Miss Lil threw the door to the Forest Club roller rink open and welcomed the youngsters to the annual Christmas Party, a five-year tradition. During the four-hour affair boys and girls—a handful seemingly too tiny to strap a pair of roller skates onto their little feet—glided around the rink, munched more than 1,000 hotdogs, consumed more than 75 cases of soda pop, blew up countless multicolored balloons, and watched more than "a million bucks" worth of entertainment provided by local nightspots—all tendered by businessman Sunnie Wilson and the efficient roller rink manager, Miss Lilian Van Buren.* Michigan Chronicle, January 1, 1949

Sunnie Wilson would take no cash donations for these parties; he asked businesses to contribute merchandise to the event: a bushel of apples, candy canes or articles of clothing. He gave children presents of bicycles, tricycles and baskets of fruit.

Even after Christmas, Wilson didn't just book entertainment and celebrities, he set up a school for poor Black people to learn to read and write. Volunteer instructors from Black sororities taught the women.

As he wrote, "Watching these people learning to write their names was an emotional experience. They had tears running down their cheeks."

Sunnie Wilson was defeated in his mayoral reelection by Roy Lightfoot, another well-known figure who owned the B&C Club on Adams Street for many years. He was chairman of the Paradise Valley Better Business Council. He also owned the Creole Chicken Kitchen (inside the Biltmore Hotel), and Long's Drug Store.

Lightfoot was a huge, three-hundred-pound man. One tradition for the mayors of the Valley was the defeated mayor had to push the winning challenger in a wheelbarrow up Hastings Street from Beacon to Gratiot. Sunnie, who was short and slight, had a struggle with this: "I had to push all three hundred pounds of him up Hastings," as Roy Lightfoot sat in the back end of the wheelbarrow, smiling all the way.

Early after being elected in 1936, Roy Lightfoot began a fund drive called the "Christmas Basket Fund," advertised in the *Detroit Free Press* on December 9, 1936, as "Negro 'Mayor' Starting Christmas Basket Fund":

> *To provide Christmas baskets for Detroit's needy Negroes, Roy H. Lightfoot, recently elected "Mayor of Paradise Valley," Tuesday announced a campaign to collect $5,000 had started....On Dec. 16, the fund will sponsor a midnight charity show at 1730 St. Antoine* [Roy Lighthouse's nightclub].

The fund drive grew, and by 1939, Roy Lightfoot was handing out 1,500 baskets.

> *Last Saturday was a big day at St. Antoine and Beacon when 1,500 or more baskets were loaded into Policemen's private cars and trucks donated by Tivoli and E and B breweries for distribution to needy families.* Michigan Chronical, *December 30, 1939*

That same year, four hundred gift baskets were distributed by the Paradise Valley Businessmen's Association. The biggest doner was Joe Louis and his manager John Roxborough. Other donors included Judge Christopher Stein of Recorders Court, who gave all court fines for three days to the fund. Police superintendent Fred Frahm donated cash and personally delivered baskets to the largest families on the list. As with the big Christmas Basket Fund, this drive was also headed by Mayor Roy H. Lightfoot. The fund continued, although Roy Lightfoot sadly died of heart failure in 1942.

CHRISTMAS SEALS

Christmas seals were at one time one of the biggest Christmas charities in existence. The seals were stamps that were sold and put on Christmas card envelopes and gifts. Like postage stamps, today Christmas seals are collected but classified as "Cinderella stamps." The Christmas seal symbol seen on stamps is the Christian cross of Lorraine with two bars (or arms, as they are termed). In 1902, at the International Conference on tuberculosis held in Berlin, Dr. Gilbert Sersiron of Paris proposed that the Lorraine Cross be made the emblem of the anti-TB "crusade." (The Lorraine Cross was the

adopted symbol by the Duke of Lorraine from France, who was one of the Christian leaders of the First Crusade.)

Christmas seals started in Denmark in 1904 as a way to raise money to build sanitaria to fight tuberculosis, which at the time was considered the deadliest contagious disease in the world; in the late 1800s, tuberculosis killed one out of seven people in the United States. It was called consumption in Europe or the White Plague, since sufferers became pale and weak. Tragically, babies and children frequently caught it. At that time, there was no cure, but sanitaria were built, offering a medical staff, healthy food, sunshine and fresh air for the victims. In short, a healthy environment was considered the best way to treat the disease. Being isolated in a tuberculosis sanitarium also controlled the spreading of the disease, as it kept the infected away from family members and the public.

One of the biggest TB sanitaria in Michigan was located in Northville at what is now Maybury State Park. It was built in 1919; however, smaller tuberculosis sanitaria were located in the city. An American, Emily Bissel,

Christmas seal from 1935. *Author's collection.*

Christmas seal from 1938. *Author's collection.*

read about the Danish charity and brought it to the United States in 1907. The program spread rapidly across the country; by 1910, the Red Cross and Association of the Study and Prevention of Tuberculosis reported seventy million Christmas seals had been sold and they were being printed at a rate of two and a half million a day. By 1911, Detroiters had purchased over a quarter million of them. They were sold in stores, schools, hotel lobbies, theaters and the post office. Movie theaters would hold intermissions at each show, and ushers would stroll up the aisles offering Christmas seals for sale.

From the National Red Cross offices, a challenge was declared:

> *A challenge has been sent from the National Red Cross society to Detroit, asking that a race for the greatest sale of Christmas seals be run with Cleveland, Pittsburg, Chicago, St. Louis, Cincinnati, Milwaukee and*

Indianapolis. Miss Maude Van Syckle, executive secretary for the Society for the Prevention and Cure of Tuberculosis, and manager of the sale this year, expects Detroit will finish close to the top. Detroit Free Press, December 2, 1913

The campaigns were effective, and the number of new facilities tripled.

The reason Christmas seals are not nearly as big a deal as they were over one hundred years ago was due to the development of the antibiotic streptomycin, which made tuberculosis a curable disease—although it would be decades before it could be considered under control.

Today, the Christmas seals benefit the American Lung Association and other lung-related issues. Tuberculosis was declining, but recently it has been on the rise. It is still one of the most common major infectious diseases in the world.

SANTA CLAUS AND THE BLIND CHILDREN

In 1923, the Downtown Lions Club of Detroit hosted a Christmas party for blind children. It was held in one of the member's houses, and thirteen children attended. It continued for decades, held at various locations around the city—the Polish Century Club, the Statler Hotel, the Masonic Temple—and at the largest event, 160 children of Detroit Public Schools attended. The Lions Club members would drive to the children's houses, pick them up and drive them home after the party was ended.

For thirty-six years, the same man played Santa Claus for that event, Benjamin C. Stanczyk. Stanczyk, who died in 2013, was a Wayne County Common Pleas Court judge and president of the Detroit Lions Club. Money was raised through candy sales at downtown Detroit offices. The children would write letters to Santa in braille, listing what they wanted. The letters were translated and read to Stanczyk. He said, "Those letters always motivate me."

He and others would get the gifts and related things. On the day of the party, the children, with their parents seated against the walls, would sit, rocking and singing Christmas carols quietly as an adult played a piano. When "Santa Claus Is Coming to Town" was played, Santa would enter the room. The kids were guided toward him, and as they reached him, some would rub their faces on the fur trim of his coat, stroke his beard and touch his face as Stanczyk talked to them. The little ones would cling to his

coat. Santa's helper would bring the children their gifts, and they were then guided back to their seats, where they unwrapped the presents. Lunch was served. Sometimes sports stars would attend, serving lunches or handing out Tiger's T-shirts, Lion's and Redwing hats or Piston tote bags.

Then it was time for Santa to go. He stood up and called to them in his big booming Santa voice, "Merry Christmas, good children. Merry Christmas to you."

And Judge Stanczyk left, rubbing tears from his eyes.

Christmas Memories

· ·

TERRY GALLAGHER

My father was a recipient of Goodfellows Christmas gifts when he was a kid, and like many others when he grew up joined the Goodfellows to help out. He was a lawyer and a judge in Detroit. He and my uncle handed out newspapers at Congress and Griswold starting in 1964 until he died in 1997, in the Goodfellows parade, actually.

I got into it with my cousin, Mike Enright, and four of five others who once worked as law clerks for my dad. We work the same corner as my dad and uncle did, then as a group, we collect the donations we've received, and send it on to the larger pool of Goodfellows collections. Our goal as a group is to earn one percent of the total Goodfellow donations, which is usually $1.3 million a year, so we work to bring in over $13,000 a season.

My dad always said if you do this you need to see the gifts being handed out to kids at least once. So, that's what I've done.

The Goodfellows rents a large conference hall off Jefferson Avenue where the gift packages have been assembled and laid out on tables. Each package contains toys, but also a "school success" package and dental kits donated by the dental association in Michigan. The packages are labeled "B6" or "G3" to indicate a boy's or girl's gift and the school grade appropriate. To receive a package the child must be enrolled in school. The family has prior to this received a letter stating that they are eligible, when the mother and children arrive at the distribution center, they need to show the letter and have identification for the child, typically a school report card or a government CHIP card [Children's Health Insurance Program].

Many times, parents arrive with preschool children, and donated toys are laid out on a table. The child with eyes wide open with a sheepish smile, look at you as if saying, "This is for me? I can just take one of these?"

"Yep, just take one. Merry Christmas."

And they do with a big smile."

Chapter 10

HOLIDAY FOOD AND
COOKING IN DETROIT

Eat some more tree ornaments

In 1960, hostesses of Christmas parties were given instructions on creating a tabletop Christmas tree made out of Styrofoam and wooden dowels. To this, appetizers were stuck on with toothpicks with dips in small bowls at the bottom of the tree. Dips included smoky dip, avocado dip and, for the weight conscious, cottage cheese dip, with the suggestion, "You might use red and green food coloring to delicately tint some of the dips."

REINDEER STEAKS FOR CHRISTMAS

In 1930, a main course for Christmas featured broiled reindeer steaks. I can just see the children anxiously picking at the steak and pondering their status with Santa Claus. Reading a bit more on eating reindeer, one writer for *Bon Appétit* in Norway described them as good, but if not cooked perfectly the meat tasted like a "funky, skunky Sloppy Joe." Along with the reindeer steaks, the 1930s menu suggested an Alligator Pear Salad. Alligator pear was a common name for avocado until the 1960s.

CHRISTMAS BAKING IN DETROIT

Of course, Christmas dinners and cooking and baking are a big aspect of Christmas: cookies, treats, candy, gingerbread houses, stollens and who can forget the noble fruit cake?

Cookies

The earliest examples of Christmas cookies in the United States were brought by the Dutch in the early seventeenth century.

In the 1796 cookbook *American Cookery: Or, The Art of Dressing Viands, Fish, Poultry and Vegetables, and the Best Modes of Making Puff-pastes, Pies, Tarts, Puddings, Custards and Preserves, and All Kinds of Cakes, from the Imperial Plumb to Plain Cake* by Amelia Simmons, she includes two recipes for cookies. This was the first cookbook authored by an American and published in the United States.

Due to a wide range of cheap imported products from Germany between 1871 and 1906 following a change to importation laws, cookie cutters became available in American markets. These imported cookie cutters often depicted highly stylized images with subjects designed to hang on Christmas trees. Due to the availability of these utensils, recipes designed to use them began to appear in cookbooks. In the early twentieth century, U.S. merchants were also importing decorated lebkuchen cookies from Germany to be used as presents.

At the end of the nineteenth century, Detroit's population of Germans had soared, consequently, German Christmas cookies, called Christmas cakes at the start of the twentieth century, were the one and only Christmas cookies. Springerles from Southern Germany, Pfeffernüsse, Ungar Brotchen, Mandelschnitten, Citroen Brotchen and Lebkucken are examples published in the newspapers. Some of these cookies were a workout for the baker.

Lebkucken—German gingerbread cookies—must be kneaded daily for two weeks for the right consistency. The German cookies have a long history, with different shapes representing Christmas or very German things. The Christmas goose had a cookie shape that was sacred to St. Martin; the horseshoe shaped cookie represented Woden's warhorse. The heart shape represented the heart of the enemy slain—and was devoured. Despite these sometimes-gruesome references, a 1906 article in the *Detroit Free Press* summarizes the tradition nicely:

Whether mythological or not, Christmas cakes have come to be a part of the American Christmas, and if you have never made them, you have missed half the joy of living, and so have your children. Try some this season and your children will rise up and call you blessed.

That doesn't happen often.

Fruit Cake

Fruit cake was a bigger deal in the past, when preserving food was difficult. Good old fruit cake, if put in a clean tin container, sealed with a lid and kept dry, would last indefinitely, probably outlast the tin container. Nowadays, many take a less than enthusiastic view of fruit cake.

They even started a new Christmas event in 1996 in Manitou Springs, Colorado, called a "Fruit cake toss," in which contestants throw old fruit cakes for distance and/or accuracy for glory and prizes. But in the old days, fruit cake was a treasure when preserved or dried fruit was the only alternative. There are lots and lots of fruit cake recipes in newspapers and old Detroit charity and church parish cookbooks. Since it was given away as a gift at Christmas, nobody ever seems to make less than ten pounds of the dough. How many baking pans did people have back then? People even had fruit cake parties for children.

The fruit cake…was our ancient custom to make the week after Thanksgiving. The younger members of the family looked forward to these bakes as gay occasions. Detroit Free Press, *December 14, 1913*

In 1917, during World War I, soldiers from Detroit who were on the front were sent Christmas boxes tied with ribbon—these always included a fruit cake. Granted, the other items were not eye-popping by our standards: some boxes included prunes, figs, raisins, dates, licorice, hard candy, salted almonds and a harmonica along with clothing and other essentials. Fruit cake doesn't seem so bad in that context.

Perhaps the oldest fruit cake recipe in Detroit was reported (or maybe conceived based on their knowledge of early cooking methods, tools and techniques) by Lucy and Sidney Corbett in their wonderful cookbook *French Cooking in Old Detroit Since 1701*, published by Wayne University Press in 1951. The recipe is not for the faint; it may seem like a cement mixer would

be a welcome kitchen appliance. You will need determination, strong arms and hands and a fanatic's love of fruit cake to get through this one.

Fruit Cake

Get out a big bowl and in it put one pound of fat salt pork, ground up. Pour over it one pint of boiling hot strong black coffee and set it aside. In another bowl mix three and a half cups of flour with one whole grated nutmeg, one tablespoon of cinnamon, and one teaspoon of powdered cloves. Work into the flour, with your hands, ½ pound of shredded candied citron, one pound of seeded sultana raisins, one pound of seedless raisins, two pounds of currants, one and a half pounds of mixed candied orange and lemon peel. Put in a pound of walnut meats, broken up coarsely, and the same amount of blanched shredded almonds. Now work in still with your hands two cups of white sugar. See that all the fruits and nuts are well covered with the flour and sugar mix. Now in the bowl with the pork and coffee, add one cup of blackstrap molasses and one tablespoon of baking soda dissolved in a little water. Beat three whole eggs well and put them in. Now add the fruit mixture and work it all together with your hands. A spoon won't do the trick as well as the hands. Now add three-quarters of a cup of good brandy and blend it in.
Baking the fruit cake is most important. This amount of stuff will make about ten pounds of fruit cake. It seems like a lot but when you make a real work of art like a fruit cake, it seems worthwhile to make enough for Christmas presents to treasured friends.

Or, in 1964, you could just go to Farmer Jack's and buy an Awrey Fruit cake, as this advertisement suggests:

Holiday Favorites
Awrey Fruit Cake and Farmer Jack's Coffee

What a rare flavor combination. Each makes the other even more appetizing. Rich Farmer Jack's coffee served piping hot is inviting in itself. But we think you'll like it even better with a slice of Awrey's justly famous fruit cake. Choose Old Fashioned Fruit Cake, an old original Awrey family recipe at $1.69.
Holiday hosting is so simple. Invite all the friends to drop by for the favorite Yuletide snack!

Freda DeKnight

Freda DeKnight was a columnist for *Ebony* magazine for twenty years starting in 1946. In 1948, she published her only cookbook, *A Date with a Dish: A Cookbook of American Negro Recipes.* It is a collection of 150 recipes from Black amateur cooks and professional chefs across the country. It is considered the first major cookbook written by an African American for an African American audience.

In her book, DeKnight presented an alternative to Fruit Cake, called Fruit Bread. It is reprinted here.

Christmas Fruit Bread

2 yeast cakes
3 eggs, well beaten
1½ cups sugar
1 pound mixed fruit peels
2 cups milk
2 cups seedless raisins
8½–9 cups sifted flour
⅔ cup chopped nuts
2 teaspoons salt
1 teaspoon cinnamon
¾ cup melted butter

Mash yeast with ½ cup sugar. Scald milk. Cool to lukewarm. Add yeast, salt and 3 cups flour. Beat thoroughly. Cover and let stand in warm place until sponge of dough is full of bubbles. Add ½ cup butter, eggs, ½ cup sugar, and remaining flour. Mix thoroughly. Knead on lightly floured board until smooth and elastic. Put into large greased bowl. Cover and let rise until double in bulk. Press dough down. Sprinkle with fruit and nuts, then knead. Divide dough in halves. Form each half into an oblong about 9 inches wide and ½ inch thick. Brush with remaining butter and sprinkle with cinnamon mixed with remaining sugar. Roll and place in greased loaf pans, 9"x5"x8". Cover and let rise until double in bulk. Brush top with a little milk. Bake in hot oven, 400°F, 10 minutes. Reduce heat to 350°F. Continue baking about 40 minutes.

With every cook, professional or amateur, DeKnight included a brief biography of the person along with some of their recipes. One man featured was Glenn Chase from Battle Creek, Michigan. Chase worked for a while in the kitchen at Detroit Golf Club and in 1916 was head chef for one of the railroad's dining cars. One of Chase's recipes DeKnight selected was for a Christmas Plum Pudding. It's copied below:

Baked Plum Pudding

¾ cup beef suet
½ cup assorted candied fruit
1 cup bread crumbs peels
¾ cup flour
1 cup milk
1 cup raisins
2 eggs, beaten
½ cup currants
1 teaspoon baking powder
½ teaspoon mace
½ teaspoon nutmeg
½ teaspoon salt
½ teaspoon cinnamon
1 jigger brandy

Mix and sift dry ingredients. Add milk and eggs. Beat well and let stand 1 to 2 hours. Stir in baking powder. Beat again. Bake in a greased baking dish 1 to 2 hours. Let cool. Pour 1 jigger of brandy over pudding. Serve with hard sauce or brandy sauce. Serves 6.

EGGNOG

Early on, housewives made eggnog for the holidays; consider this recipe from 1870.

Christmas Eggnog

Take the yolks of eight eggs and six table-spoonsful of pulverized sugar, and beat them to the consistency of cream;

to this add half a nutmeg, grated, and beat well together, then mix one third of a pint of good Jamaica rum, and a wine glass of brandy or Madeira wine; have ready the whites of the eggs beaten to a stiff froth, and beat them into the above mixture; when this is done, stir in three pints of good rich milk. No heat is used.

From *Jennie Junes American Cookery Book* by Jane Cunningham Croly

In 1959, you could have the Twin Pines milkman deliver the eggnog:

All the gifts are set out under the tree. All is quiet. Santa and Mrs. Claus are happily tired and ready for their reward. Out comes the Twin Pines eggnog…ready to pour from the bottle. Detroit Free Press, *December 17, 1959*

HOT POT

For something a bit more interesting than eggnog, Freda DeKnight offered "Hot Pot." Her book included this spirited drink from Virginia offered by the Jeters family to friends and strangers at Christmastime for three generations. As Freda DeKnight described it: "One cup of the Hot Pot and your entire body was stimulated. A trip outside in those days of bitter cold, was a battle against the elements, and a cup of Hot Pot served as a reward for those who made the trip. It was a real starter for a Merry Day and a Merry Christmas."

Hot Pot

1 dozen eggs (yolks only)
2 teaspoons allspice
2 cups sugar
2 teaspoons nutmeg
2 quarts milk
1 teaspoon salt
2 quarts cream (light)
$1/5$ quart Bourbon whiskey
2 teaspoons ginger

1 pint rum
2 teaspoons cinnamon
1 cup brandy

Beat eggs until light. Add sugar gradually and continue beating until fluffy. Add remaining ingredients, stirring constantly until mixture thickens. Never bring to boiling point. Serve hot.

CHRISTMAS TAMALES IN SOUTHWEST DETROIT

Instead of cookies and fruit cakes, the Detroiters of Mexican heritage make Christmas tamales. A lot of them. One of the centers of this activity is Honeybee Market La Colmena on Bagley Street in Mexican Town.

Honeybee La Colmena was founded in 1956. La Colmena translates to "the bee hive," and that is what the market truly is—a beautiful store that supplies families and businesses, such as local restaurants, with produce, meats and supplies.

"Holiday tamale making is a family event. A family getting together to make Christmas tamales," said Honeybee Market manager Jim Garrison. "We go through pallets of cornhusks and hundreds of pounds of masa, supplied by local tortillerias, the small masa producers in Southwest Detroit. We are the largest supplier of holiday tamale ingredients for families in Detroit." He added, "But along with traditional tamale ingredients, at Christmas families make sweet tamales, usually fruits and coconut. Pineapple is very popular."

At Christmastime, dozens of families line up to buy their tamale ingredients. Although he couldn't say exactly how much the market goes through in a season, it is not unusual to see a family leave with one hundred pounds of masa and one hundred pounds of meat. "On Christmas Eve a family will make twenty dozen tamales, for themselves or to give out as gifts to friends. One family makes 500 tamales a season, that feeds 170 family members with leftovers for gifts."

Making so many tamales is a true family affair with children grinding meat, others spreading masa (cooked ground maize dough), adding the fruit flavoring and folding the cornhusk and placing it in the steamer.

Honeybee also sells hundreds of finished tamales. "It's a lot of work. For those no longer making tamales, they buy them from us," said Garrison.

CHRISTMAS CANDY

Detroiters love candy. The city directory for 1922–23 listed 3,465 grocery stores, 650 drugstores, 461 bakeries and 1,736 candy makers and retail businesses. Six large factories that employed 1,000 women and men produced penny candy primarily for children; many candy stores clustered near schools, as described in 1917: "For almost always you can find a number of small confectioners in the immediate vicinity of any public school." During Christmas in 1921, Peter Smith and Son's Grocery store in downtown Detroit advertised that it had 40,000 pounds of candy for sale and recommended "avoid the great rush of the last few days." To name a few, there were Kuhn's Candies, Morse's Preferred Candies, the Pennington Brothers (which made "Whip-O-Lites"), Lowney's, MacDiarmid's Candies, Barbas Brothers, Cranes' Famous Chocolates and Chrystal Candy Works on Brush Street.

In 1916, the National Confectioners Association held its convention at the Statler Hotel in Detroit with the slogan, "We are makers of first-aid kits for cupid and guarantee-ors of happiness." Association members were promoting their views that candy is good food. Candy makers also pointed out that

> *any city that is consuming a lot of candy is bound to be temperate. It is known that candy eaters as a rule are not people who drink even mild alcoholic beverages....Hence, those who eat a lot of candy do not have a taste for any kind of liquors, which may be a hint to those who are trying to correct bad habits on the part of others.* Detroit Free Press, *December 19, 1917*

(This apparently ignored the fact that in some years more than one-third of city council members were saloon owners or bartenders and that during Prohibition it is estimated twenty-five thousand blind pigs operated in Detroit.)

THE PAVILION OF SWEETS

Fred Sanders opened his first store on Woodward at State Street in 1875. At the chain's peak, Sanders had fifty stores throughout Detroit and the suburbs. He began producing chocolate by the pound and eventually measured candy production by the tons. Everybody loved Sander's chocolates; when

company came to visit, out came the candy box to pass around. But it was at the holidays that Sanders really stepped up its game. Christmas candy was truly loved: foil-wrapped chocolate Santas for stockings, honeycomb chips, nibblers, butterscotch caramel topping. Sander's stockings overflowed with striped taffies, candy cane kisses, peppermint stick kisses, handmade hard candy like cherry and lime sours, Kris Kringle sticks, sweetened almonds wrapped in red and green hard candy, raspberry stufties (hard candy stuffed with Sander's own raspberry puree) and peanut butter stufties filled with pure peanut butter. Boxes of chocolates, of course, were offered, some up to five pounds in weight. They also made "center design" ice cream slices that showed a Christmas tree or Santa face surrounded by vanilla ice cream.

CHRISTMAS DINNERS

During the late nineteenth century, Christmas dinner for some was a really big production. In 1889, a Detroit publisher, Ellsworth and Brey, produced a book targeting housewives called *Queen of the Household*, by Tinnie Ellsworth, a pseudonym for Mary W. Javrin. It sold 100,000 copies nationwide. The whopping 842-page book contained every conceivable bit of advice, including menus for party dinners. Here was the Ellsworth Christmas dinner:

Christmas Dinner
Oysters on the half shell
Mock Turtle Soup
Lobster Croquettes Stewed Pigeons
Potatoes a la Reine Lima beans
Boiled Turkey with Oyster Sauce
Roast Haunch of Venison Potatoes a la Duchess
Boiled Beef Tongue with Sauce Piquant
Sweet Potatoes Oyster Salad
Roast Duck
Chicken Salad Potato Chips
Quail on Toast
Mince Pie Wine Jellies Bisque Cream
Fruits and Ices Bonbons Coffee

Remember, this is for a house party. Perhaps you're not up for the weeks of work needed for a dinner party. Many hired caterers such as Andrew Hair,

the leading caterer in Detroit in the late 1880s. Andrew Hair catered dinner parties for the wealthy and the not quite as wealthy. He summarized the differences: "In ordering a menu, two classes of society are to be considered. One for whom money is no object and for whom a special effort must be made to find something new in the way of edibles that will satisfy appetites already sated with the good things in life."

"And the other class?"

"And the other is also from society but for whom money is somewhat of an object but not necessarily the principal one, but has to be taken into account in the preparation of a feast. As a rule, a dinner with three courses, a soup, fish and roast course with dessert is usually enough even for people of wealth."

Here is Hair's Christmas bill of fare:

> *Raw Oysters*
> *Soup*
> *Kennebec Salmon Creamed Potato Balls*
> *Timbales of Sweet Breads*
> *Roast Turkey, Cranberry Sauce*
> *Cauliflower Mashed Potatoes*
> *Sorbet*
> *Canvas-back Duck, Jelly*
> *Saratoga Potatoes*
> *Lettuce Salad Cheese Sticks*
> *Plum Pudding, Brandy Sauce*
> *Ice cream in small fancy molds*
> *Cake, fruit coffee*

Freda DeKnight offered a holiday buffet in 1948:

HOLIDAY BUFFET

Red and green predominating in every conceivable combination, gaiety, the spirit of giving, store windows dressed for a parade of shoppers, Mother Nature lending her touch. If it isn't ice or snow, then it's the tropical touch of live green, real poinsettias, flowers, berries, and every imaginable form of life proving that it is time to celebrate. So, it's little wonder that at this time the Board of Gourmets have passed a law to "Eat, Drink and Be

*Merry," and this you shall do if you follow The Little Brown Chef's menu
of colorful, fabulous holiday foods!*
*Macaroni salad with whole shrimp on a bed of Romaine lettuce, molded
into a circle and decorated with parsley and pimento to resemble a wreath
of holly.*
Tomato and Green Pepper Slices around a center of Green Peas
Tiny Hot Muffins (Cranberry)
Bowl of Assorted Greens:
Lettuce—Watercress—Endive
*Hot String Beans and Chopped Stuffed Olives with Green Onion Tops in
Pimento Butter*
Tiny Individual Pumpkin Pies

SOUTHERN SOUL FOOD CHRISTMAS FROM DETROIT

As Black people migrated to Detroit, they brought with them their southern
cuisine. Soul food restaurants can be found throughout the city. During the
holiday season, soul food means Christmas for huge numbers of Detroiters.
Here are some of the holidays must-have favorites.

BAKED HAM is the centerpiece of most soul food Christmas dinners. The
crust is sweetened with honey, maple syrup or, in Detroit, Vernor's. This is
Aretha Franklin's recipe for Christmas ham:

Aretha Franklin's Vernor's Glazed Picnic Ham for Christmas

5 cups light brown sugar
5 tablespoons French's or other yellow mustard
1 cup Vernor's Ginger Ale
1 cup pineapple juice
6- to 8-pound uncured, smoked picnic ham*
To taste whole cloves (optional)
Small can pineapple rings
Small jar maraschino cherries
To taste shredded coconut (optional)

For the glaze: Combine the brown sugar, mustard, Vernor's and pineapple juice in medium saucepan. Whisk to blend well. Bring to a boil over medium-high heat, reduce heat, then simmer until reduced by $1/2$ to $2/3$. Keep an eye on the mixture and adjust the temperature as needed as it can easily foam up and boil over. Remove from heat and set aside or prepare a couple of days before you want to glaze the ham, cover and refrigerate.

*For the picnic ham: Preheat the oven to 325 degrees. Remove the picnic ham from the refrigerator. Place it on the rack of a roasting pan and let it rest, fat-side up at room temperature for an hour. Using a paring knife, score the fat layer in a diamond pattern, cutting 1 inch down, taking care not to cut into the meat layer. If using cloves, fit them in between the scored sections. Cover the ham with foil and sweat it in the oven for 1 hour. Remove the picnic ham from the oven. Remove the foil and discard. Reheat the glaze if necessary (note: it tends to set up when it's cooled). Brush it all over the ham, pressing with the brush to get it down into the scored parts. Return the ham to the oven. Roast for about 2 hours, basting every 20 minutes or until the ham reaches an internal temperature of 145 degrees. If the ham is super tough you may want to roast it a bit longer to tenderize it.

Remove the picnic ham from the oven and arrange the pineapple slices and maraschino cherries over the surface of the ham. Scatter the grated coconut over the top over all, if using.

ROAST TURKEY—Some people prefer turkey over baked ham. For big affairs, sometimes both turkey and ham are offered guests. You can skip the hours of labor roasting a turkey and in Detroit buy a fully roasted turkey at a restaurant that opened in Detroit in 1996, the Turkey Grill on Woodward in the New Center Area. The Turkey Grill goes through about three thousand pounds of turkey a week, mostly selling turkey wings. It offers turkey burgers, salads and poached turkey legs to complement its menu of fried meals. Dressing, cornbread muffins and side dishes such as macaroni and cheese are prepared daily. At holiday times, people place calls for whole roasted turkeys, which keeps the kitchen hectic, as there are often fifty or more turkeys ready for customers to pick up.

COLLARD GREENS—Traditional southern-style collard greens with ham hocks are a must for any dinner.

CHITLINS—Either you love chitlins and the way that they taste or you cannot stand the smell or even the thought of what you may be eating. They take a long time to clean and cook and are so labor-intensive that the presence of chitlins are typically reserved for special occasions and the holiday season.

MACARONI AND CHEESE—Motor City Soul Food on Seven Mile is said to be one of the top places to get this soul food favorite. The quintessential comfort food.

CORN BREAD DRESSING—Dinner is incomplete if corn bread dressing is not served.

GIBLET GRAVY—Cooks use leftover chicken gizzards and turkey necks to make homemade gravy to pour onto your mashed potatoes and/or dressing.

CANDIED YAMS—Another standard from the South. Candied yams are so buttery and tender they practically melt in your mouth.

SWEET POTATO PIE—Sweet Potato Sensations, a Detroit bakery on Lahser near Grand River in the Redford neighborhood of Detroit has made a name for itself with sensational sweet potato pies. The bakery offers other treats and a savory menu as well.

AT THE END OF THE FEAST

Dieting was never considered much until the 1920s, when fashion changed and no longer concealed one's excess flesh, as polite society once referred to being overweight. But people resisted dieting. In 1906, one woman, knowing her guests would overindulge, came up with a solution. As the coffee was provided, she passed around a candy dish that contained tablets of pepsin, said to aid digestion.

At another party, in a little speech at the end of the meal the hostess asked guests to take a pinch of salt, sprinkle it on their tongues and let it dissolve—an Arab practice done as a token of goodwill. She never mentioned

the fact, as of 1906, that salt was an excellent digestive, and guests said they had never felt so good before or after a heavy Christmas dinner.

If wine is served with dinner, it was suggested after coffee to pass around crème de menthe to lessen the aftereffects. If someone said they feel "sickish," hand them a cup of hot water to help them restore. A quarter of a teaspoon of baking soda dissolved in a wineglass of water was considered effective, but for a more serious case a dash of nux vomica in water would be served. Nux vomica was made from strychnine and seemed to be used for everything from erectile disfunction to anxiety and migraines. Today, nux vomica is considered unsafe at any dose as it affects the brain and muscles and can build up in the system if used regularly. It was recommended that the hostess have a roll of mustard plasters and hot water bottles and to know where the doctor lived.

> *Frequently the Christmas dinner leaves an aftermath of colic or acute indigestion, that may become alarming without prompt remedies. Also, have facilities for heating water quickly.* Detroit Free Press, *December 11, 1910*

Chapter 11

CHRISTMAS ON BELLE ISLE

T he moment Christmas was over, for some, the real fun began on Belle Isle as thousands descended on the island for skating, curling, ice yacht sailing and hockey. On December 26, 1897, the *Detroit Free Press* estimated ten thousand people were on Belle Isle for winter fun.

All day the Jefferson Avenue and Sherman Street cars carried boys and girls, young men and young women and a few older ones toward Belle Isle. The destination of these passengers was easily apprehended from the bundles they carried. Some had their skates done up loosely in newspapers, others had them stuffed in their overcoat pockets, while most had them suspended from their necks by straps. Arriving at the Detroit end of the bridge, the young people found covered sleighs there, and for a trifling fare of three cents the drivers conveyed them to the skating pavilion. Detroit Free Press, *December 26, 1897*

While stylish young women, referred to as Winter Girls, in their long heliotrope coats and fur collarettes stood out as they traced figure eights or waltzed the difficult "grapevine" move, according to the reporter, 75 percent of the participants were boys scrambling around on the artificial lakes then tromping off to the pavilion to get warmed up. Two big baseburners were kept furiously burning, and hundreds of young people crowded about them, taking breaks to buy something at the refreshment booths inside the pavilion.

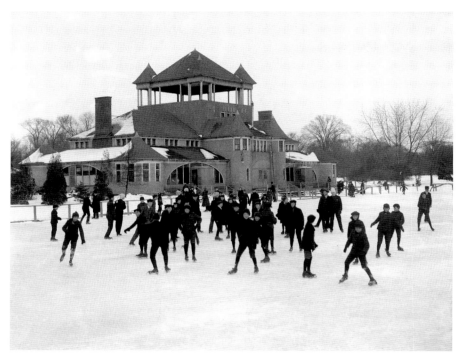

Skating at Belle Ilse 1920. *Library of Congress.*

There were "fancy" skaters who executed elaborate moves like "one husky man [who] attracted considerable attention just in front of the pavilion in the middle of the afternoon by executing the difficult and heroic 'flying three's' movement." Others included Belle Isle regular, the venerable Arthur VanDine, who at the advanced age of sixty-five was a conspicuous figure for nine years. His well-executed moves, such as a forward and backward "dutch roll" generated favorable comments from spectators.

The Detroit police had fourteen officers stationed around the island lakes, not to stop disorderly conduct but to be ready when someone broke through the ice and had to be pulled out of the water.

While Detroiters were aware of hockey in 1890s, it was seen primarily as a Canadian activity, not much more than systemized shinny, informally played in schools; however, by 1896, many cities in the United States had taken up the game and arranged amateur matches. Curling was more popular, and bonspiels were taken up on Belle Isle and across the city, where curling clubs were common and winners took home their trophies.

By 1920, the number of skaters at Belle Isle had risen to forty-five thousand. The head of parks and boulevards used a fire pumping engine to flood Detroit River water onto fifteen acres for skating. The zamboni was a "horse-drawn ice shaver to keep the surface smooth." A display of sixty poinsettias could be viewed at the horticultural building. But it wasn't always smooth skating. In 1905, the ice rinks and canal were described as follows:

> *A monotonous stretch of dull gray sky above and a sorry looking squashy rink below were not enough to discourage thousands of boys and girls that flocked to Belle Isle....But at least 2,000 boys and girls were not to be dismayed by the water-soaked ice and they made a lively scene as they sped from one end of the canal to the other, but the "speeding" was rather slow and most of the attempts to show off fancy skating stunts ended in disaster.*
> Detroit Free Press, *December 18, 1905*

Christmas Memories

. .

NADINE GILDNER LYCHUK

I'm ninety-six years old and lived in Detroit as a child in a house near the Fisher Building. I don't remember the address or street name. We had very little money. My father came to Detroit from England; my Uncle Sid lived in Detroit, so we came here to stay. That was the way it worked in those days. You usually went to places in the United States where you knew somebody who helped you find a job and make contacts. My father's first job was on a barge in the Detroit River where he sorted garbage—it's how we got our first tableware, spoons, forks and butter knives.

I remember at Christmastime we would get a package from my grandmother in England. It had a plum pudding in it that my grandmother had made with suet, raisins—a dark heavy thing— but it had silver pieces like a thimble, coins and rings that my grandmother had put in the pudding, and that was fun to eat and find the treasures.

A second thing happened before the war; we got a box at Christmas from the Goodwill. It had a doll wearing a dress that someone had made, and it had a pair of long underwear for me. I had to wear the underwear to school, but soon as I'd get away from home, I took them off. Because we only wore dresses everyone could see the underwear and I didn't like that.

We didn't have a car so one Christmas Eve my mother and I walked a mile in the snow in the moonlight to get to church for the Christmas Eve service. It was cold but very beautiful and peaceful. We had very little but every year we did get a Christmas tree. One year I bought the tree. It cost a dollar and I dragged it home for two blocks. My father was gone then and it was just my mother and me so we went to church on Christmas Eve, then on Christmas day we would go to somebody's house for fun and dinner.

Chapter 12

OUTDOOR DECORATING

Edward H. Johnson, an associate of Thomas Edison, created the first Christmas tree using electric lights in 1882. While he was vice president of the Edison Electric Light Company, he had Christmas tree light bulbs made specially for him. Johnson became widely regarded as the father of electric Christmas tree lights.

Giant municipal Christmas trees originated because electric lights made them possible. Detroit's first municipal tree appeared in 1912 by order of Mayor Oscar Marx.

However, it would be another ten years before electric Christmas lights would be commonly seen. In 1928, the *Detroit Free Press* sponsored a Christmas Outdoor Lighting Contest with cash prizes. It included Grosse Pointe and communities as far north as Royal Oak.

On Christmas Eve 1928, the *Free Press* made this announcement:

> *At 7 o'clock Christmas Eve the Detroit Free Press Christmas Outdoor Lighting Contest was officially opened, when in every section of metropolitan Detroit, lighting installations were turned on, and out of the darkness flamed the red, and green and white lights symbolizing the season, and transforming the night into a scene of magic beauty.... The entire metro area was aglow with myriad sparkling and varicolored gems.*

The contest judges were H.J.M Gryllis, architect of Smith, Hinchman and Gryllis; Ron C. Campbell, a nationally known Detroit artist; and Harry

Christmas lights in downtown Detroit. *Author's image.*

S. Lofquist of the Detroit Electrical Extension Bureau. They were looking for artistic merit (has anyone ever won an artistic award for decorating their house?). The contest made some suggestions on decorating for first timers, a sample of those suggestions:

1. *Substitute a red lamp for the customary one in your entrance fixture and put a wreath around it.*
2. *Place electric candles in a window wreath. They are far safer than the wax variety.*
3. *Run strings of colored lights through the trees and shrubbery on your grounds.*
4. *Place Christmas trees in tubs in your yard and trim them with strings of white, red and green lights.*
5. *Festoon strings of colored lights along the eves of your house.*
6. *Twine colored lights in wreaths or garlands and hang them in the windows.*

The number of contestant homes were far beyond expectations, and the rivalry of neighbors was described as "keen but in good Christmas spirit." The first prize winner of one hundred dollars was Mrs. Julia M. Barker of 19469 Cumberland Way. Her house was chosen because of the "clever distribution of lighting effects on the whole, and because it had a genuine Christmas feeling."

After announcing the winners, Gryllis, speaking for all the judges, suggested the following, which might apply to today's enthusiastic Christmas decorators:

> *There was a tendency to over decorate. The prize winners were selected because they had solved the problem of decorating their house to enhance its specific type of architecture.... The utmost effectiveness was achieved by the clever use of a few lights.*

STERLING HEIGHTS

Fast-forward seventy years to 1998. Michael Sommers of Sterling Heights was on an extension ladder as a strong gust of wind ripped off a string of lights along the roof of his two-story brown Colonial. He pressed his hand on the side of the house to stabilize himself as he tugged at the light string just as another gust of wind forced him to grab the gutter for dear life. He held onto the gutter as he listened to his extension ladder crash to the ground. He managed to hoist himself onto the roof, where he sat, unable to get down with no one home.

Then, it started to rain.

Always positive at Christmas, Sommers added, "I did manage to get everything fixed while I was up there."

Eventually, his daughter came home from school and got a neighbor, who had a hard time controlling her laughter.

Setting up Christmas lights and displays almost guarantees tension and marital strife. Leslie Sommers, Michael Sommers's wife, picked out a new display, saying it was easy to assemble, then took their girls shopping. Michael took hours to assemble the frame of a reindeer for the front yard, then another hour snapping the lights onto the frame, only to find many of the lights didn't work. He returned the reindeer to the store and came home with another one. After finally setting it up on the lawn, it worked, but every few days the lights would blink out and need a shake to come on again.

RED WING HOUSE

In Livonia in 2009, the *Detroit News* reported that Michael and Sara Tyler turned their home into a shrine for the Red Wings, including Detroit's winged wheel logo on the roof made of red colored lights that was visible by aircraft passing thousands of feet above. The house was covered in lights with players' numbers and a large purple octopus.

"There's not a day that goes by that fans don't come by, honking their horns," Tyler said. "They take pictures and really encouraged us."

SANFORD'S CHRISTMAS TREES

On May 19, 2020, after multiple days of downpouring rain, the Edenville Dam in the Saginaw Valley breached and sent a tidal wave of lake water to the man-made reservoir held back by the Sanford Dam, which also collapsed. Directly in the path of billions of gallons of raging water was a town of fewer than nine hundred people, Sanford, Michigan.

"The water began moving like in a bathtub when the drain is pulled out, dark and swirling, and we knew the dam had let go," one resident described.

It hit with such force, houses were pushed off their foundations and down the road. Main Street was a nightmare. When residents and business owners returned to the village a few days after the catastrophe, they found overturned cars, collapsed buildings and streetlights snapped in two.

Connie Methner lived in Sanford for thirty-five years, and thirty-four of those had been dedicated to her business, CJ's Hairstyling. When she

and her husband made their way back to CJ's a few days after the flood, she found out that the floodwaters had completely engulfed the shop. The water had gone all the way up to the shop's ceilings, rendering the building beyond repair.

One man who owned a car museum and dealership saw fifteen of his cars pushed out several hundred yards from the shop. Some overturned. A woman surveyed her home and found inches of thick mud covering floors, a refrigerator toppled on its side. "I just moved here a year ago. I put a lot of work into this house."

A local hospital basement flooded, knocking out power, and COVID patients on ventilators had to be airlifted to other facilities. Some never made it, and families couldn't say their goodbyes. Few residents had flood insurance since Sanford was not in a flood zone, and many residents and businesses were not covered by the disaster. The company that owned the dams declared bankruptcy and avoided liability.

Michigan governor Gretchen Whitmer soon visited the town, saying, "Getting back to normal is going to be a herculean undertaking. If there's a community that's up to this challenge, it's this one." President Trump declared the area a national emergency, and FEMA soon arrived to help, but many in Sanford faced total loss and just walked away. Some owned retirement homes on the lake, which was now a vast, reeking, depression of muck. The people of Sanford were suffering through spring and summer and fall, and now after all this, residents faced the coming Christmas season. For many it was too much.

Desperate for a sense of life they had before the flood, some took action. During the early weeks of the season, they began setting up Christmas trees along the edge of a vacant lot near downtown. More and more Christmas trees. Some were erected by businesses, churches and civic organizations. Eventually, there were sixty-two trees all covered with lights and ornaments and messages of hope. One tree had been fitted with arms that waved to passersby. One was toilet-papered high school style. One tree sang "Let It Snow." Each decorated tree told a story of Sanford. A youth sports league decorated a tree with sporting goods and team insignias; a fire department dressed up a tree like a firefighter. People on the former lake decorated a tree with retrieved lake items: paddles, toy boats, an ice chest.

Despite all they had been through, residents said they had a lot to celebrate. Homes were slowly being refitted and repainted. The post office reopened. Businesses began to come back, and shops began attracting patrons again. The holiday celebration began with a visit by Santa Claus. Mr. and Mrs.

Claus were escorted by police cars and fire trucks with lights flashing and sirens blaring. Santa then lit the twenty-foot tree as the crowd cheered. A brass band played. Carolers caroled. Cookies and hot cocoa were dispensed. Most celebrants were from Sanford, but others came to the Christmas event who were former residents, and many who had never been to Sanford hung out to show their support in some way. Even more came in cars and made a drive-by viewing of the trees, taking pictures as they circled the lot. The car caravan was nearly a mile long. Every building in Sanford was draped with Christmas lights. An American flag made of LED lights was displayed along with real flags.

Throughout the Christmas celebration, the scars of the May catastrophe were still evident: brown watermarks on homes and businesses, to roof lines in places, empty concrete slabs where houses once stood, a dirt lot downtown where a hardware had been. But it seemed the residents had found themselves.

At the Christmas celebration, they set up a six-foot heart that bore the message "Sanford strong!"

PULLING THE PLUG

Jeff and Ethlyn Unger decorated their old farmhouse at the corner of 12 Mile and Washington Avenue for thirty-five years. People drove miles and waited in traffic jams to see jaw-dropping dazzling displays of 100,000 lights and a yard crammed with inflatables and displays, some handmade. In 2013, the Ungers decided to call it quits. Even with one of their adult children helping them, it took from September to December to drag out decorations. It grew to cost $1,500 in electric bills, over $100 a year to replace burned out bulbs and strings and multiple power outages every year. They turned on the lights at 5:30 p.m. and turned them off at 10:00 p.m., 11:00 p.m. on weekends. Planning for next year's display began soon after Christmas when all was put away. Decorations and lights were stored in their garage and a large tent. After thirty-five years, it had become too much. They posted this sign to their front gate:

> *We are posting this sign to let all of you know that this will be the last year for a major Christmas display. Due to increased electricity costs and the time it takes to put the display up, we made the decision that this, our 35th year, would be the last.*

The family encouraged visitors to leave their memories, pictures and comments in a green tub beneath the sign.

Ethlyn Unger, age sixty-eight at the time, found no joy in making 2013 their last year. "I'm really sad to have it happen this way, but John and I aren't getting any younger."

It was the visitor responses that kept the lights going so long. "I keep all the letters, and one was from a woman who said she comes from an hour away, and she'll be here before it's over just for one last look," Unger said. "Another woman wrote to us saying she had fallen on hard times, and when she came out to see the lights, it cheered her up." Ethlyn Unger (also known as Mrs. Claus) planned to make a memory album for Mr. Claus. "He will so miss the lights. It's brought a lot of joy to a lot of people."

They bid farewell to a huge Santa singing "We wish you a Merry Christmas" in a loud baritone near the home's entrance, angels and nutcrackers, reindeer and candy canes, another Santa peeking out of an outhouse and yet another perched atop an igloo. A reindeer parking meter shared lawn space with a manger scene, Frosty the Snowman, Winnie the Pooh and his pals, lights and more lights and a towering Christmas tree with a lighted star on top. A digital timer on the porch counted down the days, minutes and seconds until Christmas. The Ungers moved into the house in 1978. They began with a manger scene, then a choir scene representing their eight children, grandchildren and great-grandchildren. Years of visits to big-box stores and garage sales and Ethlyn Unger's handmade decorations brought in more lights and more pizzazz. Lights put in the enormous tree in their front lawn went up in 1978 and never came down. They had lively Christmas parties in the house that were so popular passersby would invite themselves to check out the fun. The Ungers raised their eight children there, along with half the neighborhood kids as well, as their game room was quite popular.

"I always knew where my kids were," Unger said.

Their daughter Norma Unger said the following year they would probably put up the choir singers, representing family members. But most of the remainder of the display will be stored away and divided among the eight siblings. "All my brothers and sisters want their little piece of the decorations," she said.

Chapter 13

ARETHA FRANKLIN'S CHRISTMAS

*Detroit. City of my childhood, city of some of my warmest memories
and closest friends, city where I learned to sing, city of caring people
and my favorite boulevard, West Grand.*
—*Aretha Franklin, from her autobiography* Aretha: From These Roots

*She has represented her people well and super-served us with live performances,
recorded music, activism, and fierce support of the city she loves so much, Detroit!*
—*Tom Joyner*

Nobody seemed to love Detroit as much as Aretha Franklin. It had all she needed: her church, her family and friends and her music. Her love of the city was part of her character and image around the world. When Jennifer Hudson was in Detroit soaking up the city and discussing her role as Aretha Franklin in the movie *Respect*, she visited the Fox Theatre.

Jennifer Hudson was so wowed by the Fox Theatre on Monday afternoon that she couldn't help but sing. The Oscar winner was shuffling between interviews at the historic venue when she leaned over a mezzanine balcony and belted out a single note just to hear it echo around the building. "This place is so beautiful, I love it!" said Hudson, seated in a suite and looking out over the surroundings of the theater, a gem of the city that gave Aretha Franklin to the world. "I think I should live here." Detroit News, *August 3, 2021*

ARETHA AT CHRISTMAS

Aretha Franklin's passion and exuberance seemed to all come out at Christmastime, for everyone to see at her church, her Christmas concerts, her home and the lavish parties for family and friends and anyone she held dear.

Aretha Franklin. *Image by Kingkongphoto &.*

> *During this time of the year, my aunt would be finishing up her Christmas shopping in New York and Chicago, planning her annual holiday event with family and friends, selecting songs for her Christmas playlist, and talking about her menu for Christmas dinner....She loved the holidays; it was her favorite time of the year! Sabrina Owens, Aretha's niece*

In several interviews given over the years, Aretha Franklin recalled her favorite Christmas memories growing up. In 2008, CNN interviewed her on her childhood Christmas memories.

Aretha responded, in part,

> *Christmases past, my sister, Carolyn, and I—we'd been waiting for Santa all night. Nothing! Where is this man? And we're looking all up in the sky all night long, until I guess about 1 or 2 o'clock in the morning. Finally, we just fell out. We couldn't take it anymore.* [We'd wake up in the morning and] *come downstairs, and everything was under the tree! We couldn't believe it! There were dolls and tricycles, nurse's kits. I loved the nurses and doctor's kits. One of my friends calls me Florence Nightingale. Where did these things come from? You know, we just couldn't believe it.*

CHRISTMAS PARTIES OVER THE YEARS

Aretha's famous Christmas parties were covered in the press. She did the invitations by hand, inviting her family, friends and guests, such as Billy Henderson from the Spinners, civil rights leaders and church leaders. Many times, local television personalities were invited. Men wore tuxedoes, women lavish cocktail dresses. In 1985, she had a violin ensemble playing Christmas carols and a jazz band. The menus were equally famous.

"I love to throw one big party every Christmas season where I invite the people who are very, very close to me," Aretha explained. "We all get together and we laugh and we exchange gifts, we sing and we celebrate and it fills my house with love."

Aretha also mentioned that she used to enjoy catching up with old friends over the festive season and said that she was "fortunate" to have some meaningful friendships. She continued, "Another thing I really love about the holidays is that you take the time to get in touch with old friends. I have been very fortunate over the years to have made some really close friends."

Much later, she was still entertaining family and friends. CNN interviewed her in 2008:

> CNN: *What's Christmas like now? Do you cook, or do you have someone help you cook?*
> FRANKLIN: *Oh absolutely, puh-leeze! Nobody else better cook on the holidays except me! I do everything—the traditional fare. You have the turkey, the baked ham with the brown sugar glaze. We have the mixed greens, we have fried corn, we have the sweet potato pies, you have the potato salad—the whole nine yards is on the table. Everything is from scratch.*
> *Men don't like eating out of cans. And I don't like eating out of cans too much, either.*
> CNN: *Do you gather 'round the piano and sing Christmas carols?*
> FRANKLIN: *After dinner, we do. We sing a little bit. We might be playing cards; we might be playing Monopoly. The children are just running in and out of the rooms, and up and down the steps. They love the workout room.*
> CNN: *How many people do you generally have over?*
> FRANKLIN: *Usually, about 15 or so. My neighbors, my friends and family. My nieces, my grandchildren.*

Franklin said most of her family's holiday traditions are centered on cooking, but one dish will be missing from the table this holiday season. In an interview with NPR, she added: "Chitlins are off the menu," she said. "They were keeping my weight up. Chitlins have been canceled off of my list, and I know my fans and friends are screaming, 'Hallelujah!' I want to be around for a long time, so let's drop the chitlins."

But the macaroni and cheese and collard greens will stay, Franklin said.

ARETHA FRANKLIN'S HOLIDAY ALBUM, *THIS CHRISTMAS*

By 2008, even though Aretha Franklin had been recording music for nearly forty years, she had not done a Christmas album. She commented on this to promote the album.

> ARETHA FRANKLIN: *The snow is lightly falling—you get the picture— you're by the fireside with your sweetie, and no Aretha! There's no Aretha in the music! What's going on?! So, I had to do an album.*
>
> CNN: *You've been wanting to do a holiday album for a long time.*
>
> FRANKLIN: *For many years, I've wanted to do one, and I've always mentioned it to the chieftains, and they would say things like, "Oh well. Christmas albums don't sell," and things like that. But that's not the point. Christmas albums are important. The music is important. The season is important.*
>
> CNN: *On "This Christmas, Aretha," there are some traditional songs and some more contemporary tunes.*
>
> FRANKLIN: *We did "Silent Night," "Angels We Have Heard on High," "14 Angels"—which comes from the classic "Hansel and Gretel," the opera. What else did we do? "This Christmas" by Donny Hathaway and "Christmas Ain't Christmas (Without The One You Love)" by the O'Jays. Those two are my favorites.*

Aretha Franklin was recorded live on a Christmas album that was released after she had passed away in 2018. It was recorded in 2015 at Lincoln Center at a concert of big band jazz led by Wynton Marsalis. *Big Band Holidays II* from Jazz at Lincoln Center Orchestra with Wynton Marsalis is a holiday album that includes Aretha singing "O Tannenbaum,"

It is a stunning gem that features a solo Aretha accompanying herself on piano. She surprised the audience when she performed the classic melody in English and German. It was a moving, personal performance that seemed to capture those deeply still moments during Christmas and that also harkened back to her early jazz recordings at Columbia Records.

CHRISTMAS BANQUETS AND GALA PARTIES

Besides holding Christmas parties at her house, Aretha Franklin hosted full-blown galas with music, comedians and formal attire year after year

across Detroit. In 2001, it was the Detroit Institute of Arts; in 2011, it was held at the Detroit Athletic Club, where a meal of filet mignon and salmon was served to guests like Duke Fakir. The Four Tops sang Christmas carols, and Charles Scales and Franklin's son Eddie Franklin sang "Some Enchanted Evening."

Aretha Franklin hosted a glittering holiday soiree in 2016 at the International Banquet Center in Greektown, with surprise guests the Reverend Jesse Jackson and his son Jesse Jackson Jr. Jody Watley performed, and dancers from the Dance Theatre of Harlem danced to Franklin classics "Natural Woman" and "Daydreaming." And once again, Franklin's family performed, this time her singing granddaughters Victory and Grace Franklin and her son Eddie Franklin.

Her entertaining in Detroit always included both national and international stars but also local celebrities. Franklin called out to guests such as Fox 2's Roop Raj, Deena Centofanti and Huel Perkins and was quoted by the *Detroit News*: "I watch Fox 2 in the morning," Franklin said, noting their relaxed vibe approvingly. "I like their rhythm in the morning, it matches mine."

CHRISTMAS CONCERTS

While Franklin's Christmas concerts were held all over the United States and overseas, when her fear of flying began in the 1980s, some shows were put on in Detroit. Her "A Christmas Card" in 2006 featured American Idol champion Ruben Studdard and was held at the Music Hall Center for the Performing Arts in Detroit.

Franklin was interviewed by the *Detroit News* and said that appearing at this venue was especially sentimental for her:

> *"I grew up in the Music Hall," says the singer, who has previously performed Valentine's Day shows there. "My father (the Rev. C.L. Franklin) used to have services in the Music Hall when they were moving into a new church. I must have been about 9 years old. I love the Music Hall."*

She also hosted and performed a gospel concert at her father's church in 1999 called "Christmas Extravaganza at New Bethel." "You're going to see a classic, historical gospel presentation....Gospel is still very much who I am."

CHARITY AT CHRISTMAS

Aretha Franklin's charity was renowned. The final performance of her life was for a charity event to headline for the Elton John AIDS Foundation New York Gala, which raised $4.4 million. But supporting causes and charity had been a lifelong practice. In 2012, she attended a gala for the Rainforest Fund to protect the human rights in the Amazon Rainforest. She worked with Condoleezza Rice to raise money for inner-city children and promote the arts. She supported the American Grammy Foundation, Robert F. Kennedy Memorial, the Special Olympics, women's rights, research in diabetes and food banks and the NAACP.

"Being the Queen is not all about singing, and being a diva is not all about singing," she said of her fame. "It has much to do with your service to people. And your social contributions to your community and your civic contributions as well."

At Christmastime, she donated time and money both internationally and locally. She provided a free holiday feast on Christmas Eve at her father's former church, New Bethel Baptist Church; 1,200 church members were offered a buffet, including baked ham with brown sugar/pineapple glaze, oxtails, green beans and white potatoes, potato salad, pineapple upside down cake and sweet potato pies, among other delectables. "No admission for anything, and free parking, as well," Franklin said. "Come early! An Aretha presentation just for you."

In 2003, Aretha Franklin treated residents of a Bingham Farms assisted living center Arden Courts to a free concert. She brought her full performance setup, crammed into the center's activity room, including four backup singers and musicians, along with sandwiches, cold drinks and a big cake. The elderly residents all have Alzheimer's or another form of dementia.

The *Detroit Free Press* reported that Franklin sang "Winter Wonderland," "White Christmas" and gospel songs, such as "Amazing Grace" and "The Lord Will Make a Way Somehow," as the elders sang and clapped along.

One relative of a resident, Judy Marx of West Bloomfield, said, "She [her mother] enjoyed it….I could see her clapping. The music was loud and lively, those are the things my mother needs, since she can't hear very well."

Franklin said, "Music can cross language barriers, so I'm sure it can cross the barriers here."

She lived in Detroit by design. She could have lived in any city in the world, but here she was a person. When she left town, it's almost like she was on stage. But when she was in Detroit, she was the mother, the neighbor, the member of the community. We got the real Aretha.

—Vince Paul, president and artistic director, Music Hall Center

Chapter 14

BERRY GORDY, MOTOWN AND CHRISTMAS MEMORIES

Childhood Christmas memories from Berry Gordy, founder of Motown, from his autobiography, *To Be Loved: the Music, the Magic, the Memories of Motown*:

That same night I watched my brothers and sisters running off to roam the neighborhood with their friends while I sat down on the street curb remembering back to when I was almost five and thought the world was all black except for Santa Claus....

Christmas had always been the most magical day of the year for me. The night before was never one when Mother had to make me go to bed on time. As quick as it seemed my eyes had closed, they were open again. Rushing downstairs into the wonderland, I always found things I wanted.

If I didn't get exactly what I asked for, I knew it was because I hadn't been good enough. Santa was the one person I could never fool. And one Christmas I found out why.

Pushing down the sidewalk on my brand-new bright red scooter I shouted to a kid form the neighborhood, "Look what Santa brought me!"

"Junior. You know it ain't no Santa Claus, don't you?" he yelled.

"Oh, yes there is!" I replied. "And he knows when you are bad, too."

He laughed, motioning to some other kids, "Junior still believes in Santa Claus."

"Then where do all these presents come from?"

"Your father put 'em there, stupid."

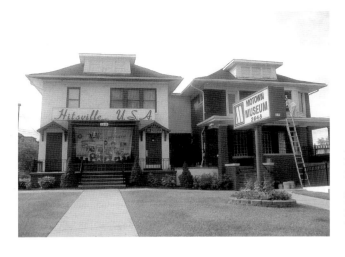

Motown's Hitsville, U.S.A., now the Motown Museum. *Wikipedia*.

I rushed home and told my sister Gwen what had just happened. When she said he was right I was devastated but acted like it was no big deal. I told her I really knew it all the time. I was dying inside, realizing the wonderment I had known on the special morning would never be again. A fraud. Betrayed by—of all people—my own parents. Why? I didn't understand how my parents could carry on such a lie and hurt me like that. I must have been real smart at that young age because after a week or so it became clear: because they loved me, and wanted to see me thrilled and happy....

A short time after that I learned the world is not all black.

CHRISTMAS PARTY 1960

Berry Gordy Meets His New Star

Hitsville was jumping. It was December of 1960, and we were having our first annual Christmas party. Everybody was there in the control room, where I was laughing it up with Mickey Stevenson and Smokey [Robinson], when Gwen found me.

"Berry, you've got to hear this guy," she said. "He's great."

Over the years my sisters were always promoting somebody.

"Not now," I said to Gwen, "Not tonight. This is our Christmas party."

"But he's good, I'm telling you." she said, pointing through the thick glass window that separated the control room from the studio.

Looking out, I saw this rather boyish slim, handsome guy. Sitting at the piano, gracefully stroking the keys in an almost melancholy fashion, he appeared deep in thought.

"That's Marvin Gaye," she said.

MOTOWN AND CHRISTMAS AT THE GRAYSTONE BALLROOM

Berry Gordy was a former Graystone patron: "I never dreamed as a kid that I'd be able to buy the Graystone Ballroom, where black people were only allowed in on Monday nights." The University of Michigan had owned it and sold the Graystone for a little more than $113,000.

By Christmas of 1962, I owned it and we began holding our annual Christmas parties there. My brother Robert dressed up as Santa Claus and went around handing out our first bonuses to employees. We also presented a "Motown Spirit Award" to the person who most exemplified what Motown was all about. Everybody in the company voted and there was always little doubt as to who would get it—either Smokey Robinson or Melvin Franklin. The first year it went to Smokey, the following year to Melvin. For five years, there were the only two people so honored.

During the rest of the year Motown would host concerts called "Battle of the Stars" at the Graystone Ballroom. As many as seven thousand people jammed the old dance hall on Woodward Avenue to see Motown Stars, like the Supremes, the Miracles, the Temptations, Martha and the Vandelas, Marvin Gaye and Little Stevie Wonder.

Through the 1960s, Motown used space at the Graystone for offices but finally abandoned it later in the decade. It stood empty for years and was demolished by the city in 1980.

STEVIE WONDER'S HOUSE FULL OF TOYS

Tonight is the celebration of the season, and you know the reason. Most of it is our experience of love to all of those children who deserve to enjoy the spirit of what we all know as little children as Christmas, Santa Clause, toys, Kwanza, Hannukah, whatever it is you want to celebrate.

—Stevie Wonder, speaking at House Full of Toys charity show, 2014

Stevie Wonder has been leading his Christmas charity show, House Full of Toys, for over twenty years. He missed 2019 due to a kidney transplant and 2020 because of the COVID-19 pandemic.

It is held in Los Angeles, where Stevie plays classic hits, Christmas songs and past albums along with invited top-level performers, such as Tony Bennett, John Legend, Lionel Richie, Sheryl Crow, Dave Matthews, Common, Andra Day, Pharrell Williams and more. The audience is asked to bring unwrapped new toys to the concert; these are collected in large trucks before the show and later distributed to children in need. Through his nonprofit We Are You Foundation, Stevie Wonder has been able to donate hundreds of thousands of toys to children, people with disabilities and families in need.

On top of collecting new, unwrapped toys, he has also partnered with the Entertainment Industry Foundation to create the House Full of Hope to raise money to support those who lost so much in wildfires, as well as the firefighters and first responders who worked tirelessly to fend off the destructive flames.

MOTOWN CHRISTMAS ALBUMS

While some artists and music executives generally look down on Christmas albums, Christmas music, both traditional and new, seemed to come naturally for a small company like Motown. It points out the family nature of Motown, when background singers were sometimes Berry Gordy's children or Diana Ross's brother Chico. The Four Tops invited their children and grandchildren on their Christmas album in 1995 (and Aretha Franklin, no less). Some artists spoke season's greetings on albums. These albums simple and genuine but with a flair and groove that still resonate fifty or sixty years later.

Over the years, Motown has released a ton of Christmas albums, many if not most of them reissues, collections and "best ofs." But no matter what they are, Motown Christmas albums are critically acclaimed and continue to sell well. In 2019, Rolling Stone included *The Ultimate Motown Christmas Collection* in its listing of "40 Essential Christmas Albums."

The first Motown Christmas album appeared in 1963 from Smokey Robinson and the Miracles, *Christmas with the Miracles*. Perhaps the most celebrated holiday album from Motown is *Merry Christmas* by the Supremes, first released in November 1965. Two years after *Merry Christmas* was released

came another album from Stevie Wonder, *Someday at Christmas*. He revised the single title track in 2015, singing with Andra Day.

The Temptations issued two Christmas albums within the space of ten years. First up was *The Temptations' Christmas Card*, issued in October 1970. It reached the Top 10 of the *Billboard* Christmas charts in 1970, '71 and '72. In 1980, the Temps produced *Give Love at Christmas*.

And Motown artists succeeded with Christmas hit singles. In 1970 "Frosty the Snowman" became a Motown classic for the Jackson 5, sung by an enthusiastic twelve-year-old Michael Jackson on their best-selling album that year, *Christmas Album*. In 1993, Motown hit the charts when Boyz II Men teamed up with singer Brian McKnight to record a version of "Let It Snow." The track was the only single from their holiday album, *Christmas Interpretations*, and reached the Top 50 of the *Billboard* charts.

Chapter 15

CHRISTMAS SHOWS IN DETROIT

Early On

Up through the early twentieth century, all shows were, of course, live, including Christmas shows. Just as today, in 1910 high schools did Christmas shows, and in that year Central High School in Detroit put on an annual Christmas entertainment that included Glee clubs singing carols but also drama, a one-act play called *Christmas in Old Virginia* and the ever-popular tableaux—reenacted posed scenes from history or the Bible. For Central High's show, they did five scenes of Joan of Arc. The student who posed at Joan of Arc was described: "Miss Kathleen Byam essayed the role of the Maid of Orleans with much effect. Her interpretation of the character seemed more fitting than some professionals."

Radio Christmas Shows

On May 4, 1922, WJR began as WCX broadcasting from the Detroit Free Press Building. Later, the station moved to the Book Cadillac Hotel and eventually to the Fisher Building. Due to the small size of the first studios, broadcasts were limited, including in the first Christmas talk shows, a children's hour with Christmas stories and carols and, the big event, a solo recital by the "Scottish Baritone" Cameron McLean, singing Christmas music sacred and secular, taking call-in requests for songs.

In 1928, WCX moved to the Golden Tower, the twenty-eighth floor of the newly completed Fisher Building, and added call letters WJR. These fully carpeted studios were spacious and could hold orchestras of fifty musicians. On Christmas Day 1928, WJR staged a Christmas party for children that featured the Skeezix kids, characters based on the comic strip *Gasoline Alley*, which began in 1918, and child performers from a musical called *King Coles Court* that was running at the Michigan Theatre.

Also in 1928 was the opening year of the magnificent Fox Theater. At Christmastime, along with the featured movie, the Fox Tillerettes danced on stage and the Fox Choral Ensemble of fifty voices performed. At night, the Fox Grand Orchestra of sixty members performed "Around the Christmas Tree."

THE MOTORTOWN REVUE

The Christmas performances of the Motortown Revue at the Fox were legendary: music fans flocked to see their hometown heroes playing four shows a day over the holidays. New Yorkers caught them around Christmas, too. In 1962—the first year that the Revue toured the United States— Motown artists including the Miracles, Marvin Gaye, the Contours, the Marvelettes, Mary Wells, the Supremes and Little Stevie Wonder played the Apollo theater for a week in December.

> *On Christmas day the Supremes will open in person at the Fox Theater, in a stage show called Motortown Revue, continuing through December 31. They headline a cast of recording stars including Marvin Gaye, the Miracles, the Marvelettes, Stevie Wonder, Temptations, Headlines, Tommy Good, the Tabs, and ventriloquist Willie Tyler and Lester.* Detroit Free Press, *December 20, 1964*

HANDEL'S MESSIAH

> *Whether I was in my body or out of my body when I wrote it, I know not. God knows.*
> —George Frideric Handel on the "Hallelujah Chorus" in his Messiah

For many Detroiters, Christmas is not Christmas without attending a performance of Handel's Messiah; for the choristers, it is the highlight of the

George Frideric Handel (1685–1759). *Portrait of Handel by Balthasar Denner. Wikipedia.*

year to sing it. When performances throughout the United States and Britain were canceled due to the pandemic, it was as if Christmas itself had been canceled.

Handel wrote Messiah in 1741 in London in three weeks. It was first performed at Easter time as an Easter oratory, in a kind of off-Broadway strategy in Dublin, Ireland, in 1742. Although a superstar at the time, Handel had been struggling with acceptance of his Italian-styled operas by an apathetic London audience. He turned to sacred oratorios, which required no expensive scenery and no hiring of difficult and expensive Italian opera musicians and singers; he once got so angry with an Italian soprano he grabbed her and threatened to throw her out a second-story window. In most of Handel's oratorios, the soloists dominate, and the choir sings only brief choruses. But in *Messiah*, said Laurence Cummings, director of the London Handel Orchestra, "the chorus propels the work forward with great emotional impact and uplifting messages." Which is also why so many churches and other nonprofessional organizations love it: the amateur singers of the chorus get a chance for glory.

In modern performances, which usually reduce the oratorio's original fifty-two sections and three-hour length by a third, Hallelujah typically comes as a dramatic flourish to end the first half before an intermission.

The earliest production I found in southeast Michigan was Ann Arbor's University of Michigan Choral Union, which first performed excerpts of the Messiah in 1849, and the first full performance in 1941. They have continued every year to this day, although they canceled due to the pandemic. The first performance of excerpts from the Messiah performed in Detroit was in 1868. Along with soloists and chorus, the orchestra was accompanied by a pedal organ. The performance was initiated by the Detroit Philharmonic Society and was given in April, much as Handel's original Easter Dublin performance.

In the nineteenth century, philharmonic societies were common in cities. They were not orchestras but organizations with bylaws and dues-paying members who sponsored concerts for the benefit of promoting fine artistic music and supporting selected charities, such as orphanages or hospitals. In Detroit, the philharmonic paid for a conductor—in the 1850s it was Senior Centemeri—and had local Detroiters as musicians. The society

advertised performances in the classified ads in the Detroit newspapers and typically held performances in hotels, such as the Russell House. While performers offered selections of operas and oratorios like Handel's *Messiah*, many concerts ended with a soloist singing "The Star-Spangled Banner," accompanied by four pianos.

> *I should be sorry if I only entertained them. I wish to make them better.*
> —*George Frideric Handel*

The attitude toward the Messiah in the nineteenth century for some could be described as complete reverence. Hearing the Messiah was way beyond entertaining. It was transcendent, a life-altering experience. An 1888 performance in Detroit received such high praise:

> *The man who is merely pleased by a performance of Handel's Messiah… without any other feeling than mere enjoyment, is cast in a defective mold. There is something lacking in his nobler nature. Music cuts us off from purely material things. It makes us forget the physical part of ourselves, and in the more perfect, yet ephemeral, development of our moral nature we learn to know more of our inner being.* Detroit Free Press, *September 30, 1888*

FORT STREET PRESBYTERIAN CHURCH

In 1971, the pastor of the historic Fort Street Presbyterian Church in downtown Detroit asked Edward Kingins to start a church chorale, and he began with a handful of volunteers. By 1988, it had grown to eighty people. Kingins joined the solo quartet at Fort Street Presbyterian in 1962. Nine years later, the Fort Street Chorale was born.

"That little group of twelve grew into a nice ensemble that averages anywhere from sixty-five to eighty people," Kingins said. He became the music director for the chorale and remained so for fifty-four years, finally retiring in 2016 at age eighty-four. In January 2022, Edward Kingins passed away at age ninety.

The group was awarded an Emmy in 1984 for a thirty-minute documentary at WTVS, Detroit and produced by Harvey Oshinsky, called *Miracle on Fort Street*. Some of the quotes that follow are taken from that documentary, which can still be viewed on YouTube.

As the former Reverend Robert Crilley said, "Fort Street Presbyterian Church has been in downtown Detroit since 1849. We start feeding [the homeless] at eight o'clock in the morning and we're not done till twelve. By the time were done, six hundred people will have been fed, clothed, gotten a haircut, shower....This church cares for people without homes. It's a refuge, a sanctuary, a place that's warm to get out of the cold."

In keeping with the spirit of the church, all singers are volunteers, and there are no auditions. Anyone can sing.

Kingins said, "We don't have any auditions. We want to provide an opportunity for people to participate in this marvelous music, in this incredible sanctuary. We have attorneys, we have schoolteachers, we have college professors, we have housewives, office workers, secretaries, truck drivers, the group is remarkably diverse. Somehow all of the barriers dissolve when you walk in the door."

The Fort Street Chorale also becomes a sanctuary for people. Milfordean Luster, soprano in the Chorale, said, "As a police officer, it's hard to deal with the cruelty, the ugliness that you see. And this chorale, at this church, is a positive."

One of the male singers added, "The thing that draws us to the Fort Street Chorale is the enthusiasm of the group, the feeling we have of togetherness with the group, because I think for the most part we are not, individually we are not that good a singer, but the thrill of the sound that we can produce when we sing together is indescribable. And you just have to do it to understand the thrill of it all."

Another said, "The idea of singing with a mixed group where you have Blacks and whites, Hispanics and what have you, it's a kind of communication where we're working together, and it's a delight to know that you can to things in harmony."

Twice a season since 1978, the church has staged Handel's Messiah using the Fort Street Chorale and the Fort Street Chamber Orchestra. Kingins said he had either sung or directed Messiah sixty times in his life.

While they are a voluntary group of amateurs, Kingins insisted they could not sound like amateurs and pushed them very hard, at times showing frustration and anger with repeated mistakes or unfocused singing as a performance date looms closer. Their Messiah performances are considered the finest in the city of Detroit.

Singing Messiah for Kingins and the Chorale members is more profound than singing other music. He spoke to them during rehearsal, "Keep the character sound, people. Don't let it collapse. If you believe what you're

singing, you cannot let that happen. Don't sing it like it's a show tune or something. Sing it with intensity, like you mean it. Some despair."

Kingins added, "As director everyone is depending on you. I sort of become possessed by this. I think about it every day. Continually."

As one member said, "This is not easy singing."

In an interview with the *Warren Weekly* in 2016, Kingins said,

> *This is a beautiful place to work on music: wonderful music, beautiful architecture. One of the recollections I have when I look back on all these years, one of the fond memories is looking up at the choir, and often the performances are very enthusiastically received; bravos, and standing ovations, that sort of thing. To see people in the choir who have never sung in a performance like that, looking at 1,000 people standing and cheering, is quite an emotional thing. Every year, I look up and see eyes full of tears, and people smiling profoundly. It's a very special Christmas gift.*

By 1999, there were Messiahs being performed in nine locations in and near Detroit. Those performances listed were the following:

Fort Street Chorale at the Fort Street Presbyterian Church, downtown Detroit.

International Symphony Orchestra and International Singers at the First Congregational Church, Port Huron.

University Musical Society with the University Musical Society Choral Union, Hill Auditorium, Ann Arbor.

Michigan Concert Chorale, Scott Hamilton, conductor, Dave Wagner, organist, Iroquois Avenue Christ Lutheran Church, Iroquois Avenue, Detroit.

Kirk-In-the-Hills, Long Lake Road, Bloomfield Hills.

Martin Luther King Jr. High School, A.M.E Bethel Church, Richard Allen Blvd, Detroit.

DeHaven Chorale, Assumption Cultural Center, St. Clair Shores and Old St. Mary's Church, Greektown, Detroit.

Rackham Symphony Choir, St. Peter and St. Paul Jesuit Church, E. Jefferson Avenue, Detroit.

And a little farther out of Detroit, the Hartland Community Chorus at the Hartland Music Hall, Annual Handel's Messiah holiday tradition! Directed by Kelli Falls. As of year 2021, the small township of Hartland, near M59 and US23, has performed the Messiah for many decades.

TOO HOT TO HANDEL

Handel really viewed "Messiah" as a work in progress. From its Dublin premiere in 1742 to the end of his life in 1759 he continued to tweak it, adjusting the instrumentation and reassigning arias from one voice to another to best utilize the musicians at hand. —Detroit News, *Lawrence B. Johnson, former music critic*

Performing Messiah or experiencing it in the audience can be a beloved tradition, or it can become merely a cultural habit, "It's what we do at Christmas." *Too Hot to Handel* blends Handel's Messiah with Detroit musical genres, everything from jazz and gospel to blues and swing. According to music critique Alex Ross, one has to look carefully at such profound changes that go way beyond Handel's "tweaking." Is it another "Fifth of Beethoven" from the disco era of American music?

Detroiters don't think so.

It was commissioned for Concordia Ensemble, conceived by the Concordia conductor Marin Alsop. A performance was given at the Lincoln Center in New York in 1993, and critics like Alex Ross, then with the *New York Times*, weren't convinced by it, but Suzanne Acton, director of the Rackham Symphony Choir (considered Detroit's longest continuously existing choir, dating from 1949), was convinced Detroiters would love this joyous, exuberant Messiah and brought it to Detroit. It was first performed at the Little Rock Baptist Church by the Rackham Symphony Choir in 2001. The first performance brought together members of the Rackham Symphony Choir, the Little Rock church choir and local jazz headliners such as trumpeter Marcus Belgrave, pianist Teddy Harris and saxophonists Larry Nozero and George Benson. The vocal soloists were Rodrick Dixon, Alfreda Burke and Vivian Cherry. A thirty-six-piece orchestra combined strings and jazz instrumentation. By the second year, they added a second performance and sold 5,500 tickets; soon the performance had to be moved to larger venues, such as the Detroit Opera House.

Too Hot to Handel is accessible to everyone. "It's not just classical music… but also jazz, gospel, rock and funk. Listen closely and you might also hear some reggae. The audience is frequently up clapping, dancing and doing all kinds of stuff," Acton said.

It is still going every year as one of Detroit's enthusiastic holiday entertainments.

MANNHEIM STEAMROLLER

Pandemic aside, Mannheim Steamroller has been coming to the Detroit area at Christmas for close to forty years. These days, there are two separate Mannheim Steamroller ensembles, which together make close to one hundred concerts in different parts of the United States. While not everybody admires the music—some have referred to it was "new age Lawrence Welk music"—but a lot of people do love it. The band claims to have sold 41 million albums, many more than any other Christmas music recording ever produced. There are six members in the band, and they are supported by a twenty-two-member touring orchestra along with laser lights and rock music–style smoke and pyrotechnics. The songs are synchronized with elaborate visuals projected above the stage on giant Christmas tree–shaped movie screens and with a variety of other effects, like the miniature blizzard that is unleashed on the audience by snowmaking machines installed in the rafters. But the concert is more than music, it is what the band likes to call "the complete Mannheim Christmas experience," a full immersion in holiday glitz. In some years, carolers roamed the halls outside the concert hall. Santa hat–wearing ushers distributed programs. Balconies were festooned with holly. There has even been a two-thousand-square-foot "Christmas village" diorama: a snow-dusted Old World hamlet inhabited by dolls and encircled by a miniature train.

The founder of all this now lives in Omaha, Nebraska, but has connections to Michigan. Chip Davis was from a small town in Ohio, near Toledo. His mother and father were musicians, and Davis took an interest in music and performing about as soon as he could sit up; he wrote his first song when he was six years old (about his dog, Stormy). When he was eleven, Davis was given the chance to join the Vienna Boys' Choir (his parents wouldn't let him go); by age sixteen, he was filling in occasionally on bassoon in the Toledo Symphony. He played the bassoon and after high school attended the School of Music at the University of Michigan in 1965; both his parents were graduates of U of M music school. He played cymbals in the Michigan Marching Band, like his father, and at football games he claimed his knees shook when he marched out onto the playing field at half time. He also sang in the University Musical Society's Choir Union. He has had the University Glee Club sing on one of his albums.

When he graduated in 1969, he was strictly about classical music, but he took a job with the Norman Luboff Choir, singing tenor and soaking up Luboff's eclectic easy-listening repertory. "When I was in college, I was

so straight classical. Norman got my mind open. We sang everything: pop songs, cowboy songs—and Vivaldi."

He sensed the popularity of a mix of classical and pop songs and to this day uses ancient musical instruments, such as a harpsichord and a fifteenth-century reed instrument called a crumhorn in combination with 1970s-style amped-up drums and synthesizer. His fusion of rock with old classical pieces he called "Fresh Aire."

However, on top of his musicianship he is also a passionate entrepreneur. He founded his record label, American Gramaphone, when major record producers turned down his first recordings and claimed doing a Christmas album would kill his career. He's very attuned to everyday activities of people. Instead of selling the CDs in music departments only, he tries to place them where people, especially women, whom he claims make music decisions for their families, are buying other related items. So, for a CD of patriotic music called *American Spirit*, he placed his CDs in supermarkets near hotdog buns and shoppers grabbed them as they bought other items for parties or family gatherings near the Fourth of July. He sells CDs in drugstores, greeting card shops, truck stop, and sporting goods stores. He has had exclusive deals with chains like Lowe's home improvement stores.

His market savvy has made him one of the most successful recording artists in the history of American music. Davis has racked up these astonishing sales figures operating out of his home in Omaha, Nebraska. On top of that, Davis has a line of nonmusical products with the *American Gramaphone* "clothing and lifestyle" mail-order catalogue. There is the Mannheim Steamroller Bath and Body Basket, a collection of scented candles and beauty items; Bry, a spray-on barbecue sauce that Davis invented in his kitchen; and Mannheim Steamroller Cinnamon Hot Chocolate, Davis's most popular food product. There are Christmas items from "20-Year Collectors' Edition" Mannheim Steamroller Christmas ornaments ($49.98) to wind-up "Gigantic Musical Christmas" snow globes ($79.98).

"I feel honored and humbled that millions of people have involved me in their families at Christmastime, involved me in their thought processes," Davis said. "I'm just a small-town Midwestern musician."

Several years ago, Steve Shipps, a featured violinist with Mannheim Steamroller since its beginning, came to him with an unusual proposal. Shipps, a professor of violin and senior adviser to the dean for International Study at the University of Michigan School of Music, Theatre and Dance, asked Davis if he would donate money to build a multimedia innovation lab at the school.

"I decided it would be an exceptionally cool thing to do since I was in the first class to use the Music School building when it opened," Davis said. In 2015, he contributed $1 million toward construction of the Chip Davis Technology Studio.

THE NUTCRACKER

In the nineteenth century, the most famous conductor of orchestral music was Theodore Thomas. He was born in Germany in 1835 and was a gifted violinist, performing on major stages across Europe at age six. His father was a German band leader and in 1845 immigrated with his son to the United States. As in Europe, Thomas gave solo concerts. After a year, he returned to New York in 1850 and was hired by the New York Philharmonic, where over the years he played as first violinist with the most famous soloists and singers. In the 1850s, he trained as a conductor and in 1864 founded the Theodore Thomas Orchestra. The orchestra had several financial difficulties, and in 1890 a group from Chicago offered Thomas a permanent orchestra if he came to start Chicago's first symphony. He agreed and began in 1891. Thomas was also important because he frequently featured new work from then unknown composers, such as Anton Bruckner, Antonin Dvorak, Edvard Grieg and Pyotr Tchaikovsky. Tchaikovsky was very appreciative of Thomas for promoting his work; Thomas was second in the world to premiere the Nutcracker suite in 1892. Before the original performance of *The Nutcracker* ballet, which many critics didn't like, Tchaikovsky put together the various tunes in the ballet into an orchestral piece he called the Nutcracker Suite.

As head of the Chicago Orchestra, Thomas gave tours to cities in the Midwest and came to Detroit through the Detroit Musical Society to perform the Nutcracker Suite on November 22, 1892.

The programme selected for the occasion could hardly be improved upon. It caters to all tastes from the severely classical to the admirers of waltz music. It presents numbers entirely new to the United States. The first is a suite from Tchaikovski's latest ballet, called the "Nutcrackers" [sic]. Detroit Free Press, *November 13, 1892*

In 1907, the Nutcracker Suite was performed in Detroit at the Light Guard Armory by the New York Symphony Orchestra. In 1910, Russian ballet was first introduced to American cities with a tour by Russian

Great Russian ballerina
Anna Pavlova in the 1920s.
Library of Congress.

ballerina Anna Pavlova, ten additional soloists and the Imperial Russian Ballet with an orchestra of fifty-five musicians. The entourage came to Detroit, at the Lyceum Theatre on Randolph Street, and it was a sensation. While Pavlova did not dance the entire *Nutcracker*, she did an excerpt called "Snowflakes" (which we call today Dance [or Waltz] of the Snowflakes) for matinee shows aimed at children. She was so popular and pleased with the Detroit performances she continued to come back to Detroit until 1926, sixteen straight years. The staging of the "Snowflakes" was described in 1925:

From the scenic standpoint, the beautiful "Snowflakes" ballet in one act, with boughs bending beneath their burdens of snow, and the tiny flakes falling throughout the action, commends itself strongly from the visuality of its setting. Detroit Free Press, *January 20, 1925*

By the 1920s, the Nutcracker suite had become commonly performed in Detroit; in 1920, the Detroit Symphony Orchestra played the suite in Orchestra Hall.

Of the movements of the Nutcracker Suite the verve of the Dance Russe, the sensuous charm of the Dance Arabe, and the special charm of the Valse des Fleurs called forth special applause though the entire number was given with captivating appeal. Detroit Free Press, *February 2, 1920*

However, the ballet in its entirety was not performed outside of Russia until the 1930s and staged for the first time in the United States in San Francisco on Christmas Eve 1944. But it didn't become a huge Christmas tradition until 1954, when the renowned choreographer, George Balanchine, staged it in New York City. The story of the was written by German author E.T.A. Hoffman. It was slightly creepy with pedophilic overtones of the godfather, Herr Drosselmeyer, and odd dreams of Clara, the main character. What Balanchine did was made the tale a family-centered story with a father who dances with his young daughter, a mother who comes to the rescue of a son when he is left without a dance partner and other happy, idealized family Christmas scenes. He also choreographed thirty-five roles for children as

toys, having a party or hiding under skirts of Mother Ginger. This clever change had immediate appeal to children and their parents, and for many children it is their first exposure to ballet and classical music. For lots of kids, *Nutcracker* is their first experience performing onstage. It also didn't hurt *Nutcracker*'s popularity that it was broadcast on national television in 1957 and 1958 at Christmastime.

Over the years, several ballet troupes have developed their own version. In 2006, three separate performances were given in Detroit at Christmas.

Moscow Ballet's version of the *Nutcracker*, known as the *Great Russian Nutcracker*, is performed in Detroit and other cities in Michigan. The Moscow Ballet's Great Russian Nutcracker at the Fisher Theatre featured an all-Russian cast and was directed and choreographed by Anatoli Emelianov, who set Act II in the "Land of Peace and Harmony" and introduced a new character—a dove that leads Masha and the Nutcracker Prince to the new land.

Joffrey Ballet's version is described as a sparkly *Nutcracker*. The acclaimed Joffrey Ballet's *Nutcracker* included performances from more than eighty local children. The Joffrey *Nutcracker* is set in America and features lavish Victorian scenery and costumes.

Finally, the Detroit Symphony Orchestra's premier youth ensemble, the Detroit Symphony Civic Orchestra, teamed up with Taylor Ballet Americana and principal dancers from the New York City Ballet to present three performances of *The Nutcracker*. In that production, they offered a special abridged version, suitable for children ages three to six, performed as part of the DSO's Tiny Tots concert series.

MAKE TIME FOR JOY—THE ROCKETTES RADIO CITY SPECTACULAR

The Radio City Christmas Spectacular started in 1933 but first came to Detroit in 1996. It has become the Christmas tradition for thousands of families in Metro Detroit.

The thirty-six performing Rockettes, dancing Santas, ballet dancers, skating couples and five sheep, three camels, two donkeys and one dog do four shows per day. The animals don't do any kicking—that is only for the Rockettes at three hundred kicks per show, many of them "eye high" kicks for fifty-four shows per season. One Rockette at a rehearsal wore a fitness tracker and learned she was burning one thousand calories per

The Radio City Music Hall Rockettes. *Photo by Bob Jagendorf. https://www.flickr.com/photos/ bobjagendorf/4158767098/*

show. To do this and maintain their equally famous continuous smiles, the Rockettes rehearse six hours a day, six days a week from beginning of November to the start of the run at the end of the month. The expansive smile is achieved by relaxing one's face, softening the tongue, breathing only through the nose and raising the eyebrows. One of their poses is called "sunshine head": the smiling face is tipped up at an angle as if were bathed in glorious sunshine.

Of course, they are famous for their precision. The concept of the precision dance line is to maintain absolute uniformity. The audience sees the Rockettes perform intricate routines, always moving as if one dancer. Everything from the dancers' height, the costumes and steps are meant to look completely identical. Krystle Richeson, a Rockette from Farmington Hills, said in 2008 that she would get a note from a director if one of her fingers was even an inch out of place.

The women's hairstyles are the same: pinned into a French twist. Since short hair is not permitted, this is the only way dancers can fit into the several hats they change into during a show. As the Rockettes rehearse, the dance captain consults huge binders containing 250 pages of charts and numbers. They count and check each turn of the hand, twist of the head,

jump in the air, landing position. In some numbers, every arm thrust or kick is accentuated with the hit of a cymbal from the orchestra; nothing is spontaneous or improvised.

Some of the show has never changed. In fact, two scenes in the show are performed with the same choreography as they were when the show began. "The Parade of the Wooden Soldiers," a precision military marching routine, has been performed in Radio City's holiday show each year since 1933. "The Living Nativity" has also been a part of the Radio City Christmas Spectacular for seventy-five years. However, the show in Detroit is customized a bit for the opulence of the Fox Theatre, such as ten thousand more twinkling lights. It takes ten tractor trailers to bring the sets, costumes and live animals to Detroit. From year to year, most shows have between seven and nine costume changes. Between the "Parade of the Wooden Soldiers" and "New York at Christmas," the Rockettes have just seventy-eight seconds to change outfits. That means taking off socks, shoes, pants, jackets, gloves, red cloth cheeks and hats and then putting on dresses, shoes, jackets, earnings, gloves and new hats. They know when they should be dressed and ready to be back on stage by music cues from the orchestra. For the tap-dancing numbers, wireless microphones are hidden in their tap shoes' arches.

The show's management insists that there is no weight requirement for Rockettes; instead, they undergo general health testing that includes "all sorts of things." The director in Detroit, Russell Markert, was quoted in 1993:

> *The qualifications to become a rocket are as follows: 5'5" to 5'8" in your stocking feet and a good trim figure. Good ballet foundation, exceptionally limber kicks, and advanced tap and modern jazz.* Detroit Free Press, *November 8, 1993*

In nearly thirty years since that quote, the height of the dancer requirements has risen, and is now: 5'6" to 5'10.5".

But of course, uniformity of appearance is a priority. They emphasize that want healthy dancers who can do the work. Nor are the dancers asked their age. Some dancers have been Rockettes for thirteen years, and many are mothers. One Rockette dancing at Christmas is a mother of three; another had a baby five months before the rehearsals of the show. Everything is based on the ability of the dancer to endure the grueling workouts and shows.

The Rockettes did not have an African American dancer until 1985. Now, 27 percent of Rockettes are ethnic minorities, and Radio City is working to recruit more dancers. They feel it's a priority that the Rockettes' dance line reflects the audience.

Chapter 16

CHRISTMAS NEAR DETROIT

The Ford Rotunda

The 1930s were probably most famous for the stock market collapse and the Great Depression, breadlines, soup kitchens and general misery for many people, a result of the credit-crazed Roaring Twenties. Business leaders were worried that lack of jobs and breadlines were going to destroy America's confidence, spirit and industry. Chicago leaders devised a world's fair that would promote science and industry and a wonderous near future. It would open in 1933 and be called "A Century of Progress Industrial Exposition." (The century anniversary was that of the city of Chicago, which was founded in 1833.)

It included a Hall of Science that would give the fair its unofficial motto: "Science Finds, Industry Applies, Man Conforms." After all, the internationally famous Columbian World's Fair held in Chicago in 1893 had put Chicago in the big leagues. They would do it again in 1933. But unlike the 1893 fair, which boasted the famous White City with nine all-white pavilions, Beaux-Arts in style and modeled off great buildings of the past from around the world, the 1933 fair would feature two dozen corporate structures of futuristic design, sophisticated and colorful promoting the latest gizmos and innovations for automobiles and homes. The biggest among those structures was Ford Motor Company's "Wonder Rotunda."

The fair heavily featured auto companies, as announced by the *Detroit Free Press* on April 30, 1933:

The Chicago World's Fair poster—"A Century of Progress Industrial Exposition," 1933. *Wikipedia*.

Chicago's 1933 World's Fair—a Century of Progress—will present the greatest automobile show in the history of the automotive industry.... The World's Fair's great automobile show will display everything that is new in motor vehicles, thus furnishing a stimulus needed to loosen tighten purse strings—to start the motoring public to buying new cars.

It would run for five months: June to November. Auto companies big and small eagerly signed up. The big companies built enormous, modernistic structures in the best Art Deco style of the times. Chrysler spent $500,000 for its pavilion. GM featured an entire Chevrolet production line producing thirty cars a day while spectators walked on platforms twelve feet above.

However, Henry Ford wanted nothing to do with the expo, considered it a waste of money. The fair was a huge success, so much so that an enthusiastic President Franklin D. Roosevelt persuaded the Chicago directors to extend the fair another year. They agreed. Henry Ford saw the success GM and Chrysler were having, so he jumped in as well. But the company had to hurry. Ford hired Detroit's legendary architect Albert Kahn to design the company's pavilion. Kahn created a cylindrical structure modeled on a cluster of meshed gears. It was described as a "dazzling performance of architectural effort" and a "tribute to structural perfection." It was a round steel frame encased in white plaster with side wings. In total, the structure spanned 900 feet long and 213 feet wide and rose to a height of twelve stories, taking up more than half of the eleven acres of land given for the Ford exhibit. Attendees visiting the outdoor area at night were also treated to a rainbow light show across the exterior façade of the hall by nine thousand spotlights and enormous beams of light that shone a mile into the night sky. The entire pavilion was constructed in three months.

Henry Ford said, "At our exhibit, we intend to show the How of Progress. How things are done." In keeping with the fair's overall theme of technological innovation, Ford teamed with manufacturing suppliers to create five main areas of display around the ring of the interior building wings. This included forty processes that produce parts for a Ford vehicle from pressing red hot ingots into rolled steel, to weaving and cutting fabric for car seats, to growing soybeans outside the building to be used in automobile paint and parts. Around the walls of the Rotunda was a mural called *The Drama of Transportation*, which presented the history of vehicles over the centuries.

The center of the Rotunda was left open to the sky, a courtyard, where the sun shone down on a twelve-thousand-pound giant world globe,

The Ford Rotunda, Dearborn 1954. *Author's collection.*

twenty feet in diameter, showing Ford's activities around the world, Ford's universality. The sites would light up as the globe slowly rotated on the tilted earth's axis.

They called it the Wonder Rotunda, which sounded like the name of a gigantic gas-guzzling car from the 1950s but is actually Latin (*rotundas*) for "round" and used in architecture for large round domed buildings like the Washington, D.C. Capitol. The Wonder Rotunda was a smash hit—twelve million people wandered through it. Ford had to keep hiring more help, and by the end of the fair 1,300 worked there daily. It was so popular Ford decided to pack it up and ship the steel frame to Dearborn, where it would act as a visitor's center, a showcase for new vehicles and, importantly, what would become the best place in the world to enjoy Christmas and visit Santa.

THE FORD ROTUNDA COMES TO DEARBORN

In 1935, Ford shipped the steel frame of the Rotunda to Schaefer Road. Because the plaster board shell of the building was never meant to last beyond a year, it was redesigned with Indiana limestone panels. Detroit's architectural sculptor Carado Parducci decorated the building with carved stone metaphorical figures. Inside, Detroiter Ruth Adler Schnee, who

Night view of the Ford Rotunda. *Wikipedia.*

attended Cass Technical High School and the Cranbrook Academy of Art, designed the fabrics for the Rotunda.

Initially, Henry Ford wanted it placed in Greenfield Village, but his son, Edsel, convinced him it would be a better fit as a welcome center for visitors touring the Rouge Plant. As in Chicago, in Dearborn the public loved it. On May 16, 1936, twenty-two thousand people attended the opening day. It would become the fifth-most-visited site in the United States by the 1950s. It was more popular than the Smithsonian Museum and Lincoln Memorial.

In the 1950s, the Ford Motor Company decided for the fiftieth anniversary of the company to build a cover for the center open courtyard where the giant globe had sat to get more utility out of the building. But the building was not designed to support the weight of a ceiling, and the cost of alterations would be expensive. The famous engineering innovator from MIT R. Buckminster Fuller proposed his new patented geodesic dome, which was lightweight and much less costly: Fuller's dome was created with 19,680 aluminum spars and weighed 17,000 pounds; a steel beam dome would have weighed 325,000

pounds. Fuller developed the aluminum dome after years of strengthening wings and fuselages of large aircraft. Before it was put in place, it went through rigorous strength testing at the University of Michigan. Due to its light weight, Fuller suggested it be floated by balloon to the top of the building. This was Fuller's first commercial application of his dome. It stood 109 feet above what would become the "Inner Court."

CHRISTMAS FANTASY

It lasted only nine years, from 1953 to 1961, but over that period Christmas Fantasy attracted over six million children and their parents to see Santa Claus. Its signature attractions were elaborate animatronic scenes. These were created by Silvestri Art Manufacturing Company of Chicago, which specialized in department store window displays across the United States. Another unique feature were two thousand dolls that encircled a long wall, dressed by members of the Ford Girls' Club. It was also a contest, and winners were highlighted in a special display façade called the "Doll Dressing Contest." Before Christmas, the dolls would be removed and distributed by the Goodfellows to needy children. Around the back of the Rotunda outside were live reindeer: Donner, Blitzen, Prancer and Dancer.

Christmas Fantasy opened on December 15, 1953, and through the Christmas season that year 500,000 people came to see it. It started with the reindeer, a thirty-seven-foot Christmas tree with a village snowy scene at its base and the first animated display—Santa's Workshop—which featured a group of tiny elves working along a moving toy assembly line. Over the years, scenes were added and became larger and more elaborate. Life-size children's figures in Story Book Land like Hansel and Gretel, Robin Hood, Wee Willie Winkie and Humpty Dumpty moved back and forth in wintry Christmas settings. In 1957, two animated scenes were added to the display of dolls: a Beauty Shop, where two beautician elves made a pair of dolls stunningly beautiful, and a Dress Salon where elves operated a sewing machine and iron. More displays were added in 1958, a Pixie Candy Kitchen. Animated candy makers turned out over-the-top chocolate-covered treats, and a Bake Shop featured nine animated bakers kneading dough, trimming pies, mixing cakes and baking bread and cookies. In another display, a fiddler and banjo player accompanied a group of square-dancing elves in a barn dance scene. In 1960, animated jungle animals moved about in cages with peppermint-stick bars.

Child's souvenir booklet given for a visit to the Rotunda, 1962. The cover shows Santa driving a Ford Falcon Squire station wagon. *Author's collection.*

In the Rotunda's walled-off inner court where the giant globe once stood, visitors entered through a cathedral façade, with bells ringing from forty-foot spires. Inside the court was a nativity scene with life-size figures. An organ set alongside the nativity scene provided Christmas music while Detroit-area and Dearborn high school choirs and choral groups gave concerts.

A new attraction was added in 1958: the fifteen-thousand-piece miniature circus, created as a hobby over sixteen years by John Zweifel, from Evanston, Illinois; he started it when he was fourteen years old. Each piece was hand-carved and came complete with performing animals, a circus train, sideshow attractions, carnival barkers and bareback riders. Larger-size animated circus animals and a clown band provided the backdrop.

Zweifel started making miniatures at age four, whittling objects from cardboard and carving figures out of bars of soap. He also created a miniature White House during Gerald Ford's administration that toured the world.

Of course, one had to visit Santa to make the visit complete. In the Rotunda, Santa was in a colorful, enchanted castle, and children with parents waited on a long, curved ramp to see him. After a visit, each child received a souvenir to take home.

Many sat in the auditorium to watch free cartoons and movies. By 1960, over one million people from across the United States and overseas were visiting the Christmas Fantasy. It became the fifth-most-popular tourist destination, after Niagara Falls, the Great Smoky Mountains National Park, the Smithsonian Institution and the Lincoln Memorial. It was more popular than Yellowstone Park, Mount Vernon, the Washington Monument and the Statue of Liberty.

THE FIRE

Returning to R. Buckminster Fuller's aluminum dome, while it did cover the 112-square-foot inner space with less surface material, it was difficult to find something to make it waterproof. In short, it leaked. When preparing for the Christmas Fantasy of 1962, the dome was being recoated with mastic and fiberglass. To do this, roofers used hoses attached to an air compressor on the ground that pushed the heated liquid mastic from a fifty-five-gallon drum to a smaller tank on the roof that was likewise heated with a propane tank and infrared heater. A layer of mastic was sprayed from a second hose onto the dome; the men then

pulled a thin sheet of fiberglass onto the hot sticky surface and covered that with another layer of mastic. The fire department of Dearborn in its final report stated that the fire was caused by fumes rising from the heated tank of mastic and the propane heater on the roof. Once the fire started, one roofer grabbed a fire extinguisher but quickly realized the flames had spread across the entire tarred dome. They knew it was serious and got down immediately.

Tom Skelly and his crew were busily setting up the Nativity Scene directly under the dome; one million visitors were expected that year. It was November 9, and Skelly was running out of time; the Christmas Fantasy was set to open on November 24, so he and others hurriedly carried the three wise men and stood them before the manger bearing their gifts. It was then that he noticed something odd and alarming: "little beads of fire" were dropping from the dome. He watched for a few moments, telling himself that they were just occasional droplets caused by the roofers and their waterproofing work. He had the crew move larger-than-life camels out of harm's way.

"We didn't think the whole building was in danger," Skelly said in an interview.

Then they noticed Christmas decorations were catching on fire as the droplets got bigger and came down faster. He ordered everyone out.

It was later described in the newspapers as "a roaring volcano." It completely collapsed the Rotunda in forty minutes. Amazingly, no one was killed and only one man was hurt when he rushed in to shut off the gas to the building: his injuries were not serious. If it had happened in December with the building packed with children and adults, it would have been a horror story. It started at 1:15 p.m., and many people were still at lunch. The entire dome collapsed, and fire rose up behind the panels of limestone. Within thirty minutes, the limestone panels and concrete lining began to crack as the heat warped the steel frame, which began to buckle. The walls opened and collapsed and crushed the Christmas displays, leaving the steel frame a twisted, smoldering ruin. In one of the building's wings, a dozen 1963 new model Ford automobiles were destroyed as the walls of the south wing burned to the ground. The north wing, which had a thick firewall, was spared. This was fortunate, since the entire Ford archive of 9 million irreplaceable documents and 450,000 photos of the company's history were not affected. The Christmas tree had not been delivered, and the 2,000 decorated dolls were not yet in the building, so the Goodfellows could still deliver them to children. Cost of damage was $16 million ($148 million in today's dollars).

Henry Ford II announced the company would put up an enormous Christmas tree in front of Ford Headquarters, the Glass House, on Michigan and Southfield so children would have something to enjoy that year, but it would not rebuild the Rotunda. The company had spent its budget at the New York World's Fair that year.

Through all of this, at no time did Ford charge an entrance fee or attempt to sell novelties or food services at the Rotunda. It was a way to show off Ford's new cars, but the Christmas Fantasy had been solely a gift to the public and the public knew it.

Bronner's CHRISTmas Wonderland

Bronner's CHRISTmas Wonderland in Frankenmuth, Michigan, was begun by Wallace "Wally" Bronner. Wally Bronner had a talent for painting as a young man and began his adulthood as a sign painter. In the early 1950s, he was painting signs for a large hardware store, Jennison's in Bay City, when a man from Clare, Michigan, came to the hardware looking for Christmas decorations to adorn the lamp posts on the city's main street. The hardware didn't carry such things but handed the opportunity to Wally, who painted up some colorful Christmas panels with candles, Christmas trees and such for the Clare merchants to consider. The city liked his artwork and agreed to his proposal, which launched his Christmas business in Frankenmuth—"launched" like a "rocket launch," as Bronner's CHRISTmas Wonderland went far beyond anyone's imagining. An old school chum helped him contact mayors, city councils and city managers throughout Michigan to make the new enterprise known. Wally decided he needed an exhibition for the large decorations, which now included lights and streamers, life-sized nativity scenes and more. He started in an abandoned school building. Being a natural hustler, he offered any visitors to the exhibits a free chicken dinner at Zenders or the Bavarian Inn, both in Frankenmuth. Like Bronner's, enjoying a chicken dinner in Frankenmuth was also becoming a Michigan destination. At the time Wally started in the school building, Zenders and the Bavarian Inn were serving five hundred to one thousand chicken dinners on Sundays. Today they serve close to forty thousand per week.

People arrived and placed orders for six-foot candles, eight-foot candy canes, life-sized carolers, Santas and reindeer. And very soon Wally Bronner would be looking for more expanded space, something he did for his entire

Bronner's CHRISTmas Wonderland, west entrance, in Frankenmuth, Michigan, by Andrew Horne. *Wikipedia.*

business career. By the mid-1960s, he occupied three sites: the Tannenbaum shop in a former bank, the Bavarian Corner in a storefront in town and the Main Store in a large storefront in the center of Frankenmuth.

In the mid-1970s, he bought property south of town and put up the structures used to this day, still adding and expanding until it was the world's largest year-round Christmas store, covering 2.2 acres (1.7 football fields). The landscaped grounds cover 27 acres, with 7.35 acres (5.5 football fields) of building in Bronner's entire complex. Throughout the complex and grounds, 100,000 lights twinkle, and 300 decorated Christmas trees are displayed. Bronner's Hummel collection has over 1,000 figurines, one of almost every subject by Goebel, the manufacturer in Germany. A total of 570 Nativities from 65 nations are part of Bronner's collection on display in the program center.

The parking lot holds 1,440 spaces. Many come by motorcoach, and Bronner's claims 2,000 motorcoaches stop at their CHRISTmas wonderland a year. Through the year, over 2 million people visit Bronner's from all around the world, and at their busiest time of year, right after Thanksgiving, Bronner's gets 50,000 visitors a day. At the season's peak, 700 people work at Bronner's. It is in the top ten tourist attractions in Michigan.

How did Bronner's happen? To understand that you would have to know Wally Bronner. He was a tireless entrepreneur, working constantly. "I work every day that ends in a 'y,'" he said. He also held the wide-eyed wonder of a young boy with his nose pressed to the frosty display window at Christmas. He was a deeply religious man and devoted to his German heritage in a town founded by Lutheran German immigrants in 1854, more specifically, Franken people from Franconia in central Germany (*muth* means "courage" in German, so Frankenmuth means "the courage of the Franken people"). They came to the Saginaw valley, then timberland, to settle and to convert Chippewa Indians to Lutheranism. While Wally did well on the commercial side of Christmas, he was always reminding everyone of the essential spirituality of the holiday, "keeping Christ in Christmas." It was Wally who created the trademark Bronner's CHRISTmas Wonderland. The company mission statement came from a Christmas card he and his wife received early in their marriage: "Enjoy CHRISTmas, Enjoy Life, It's HIS birthday, It's HIS way." Wally's passionate belief in God gave him a solid confidence that he was doing the right work, for the right reasons, and God was good and had a plan for him, for his family and for all people. Yes, it is commercial and makes the company a lot of money, but Wally points out that he makes sure everything he sells is "Lord-pleasing." "We try to make sure we put Christ foremost in Christmas" It's a religious certainty and unabashed enthusiasm that seems to be less common today than it did in the past. The thought of celebrating Christmas every day of the year for your entire life can make one woozy; Wally not only endured Christmas but also thrived in it. He never tired of ornaments and holiday stuff; whether new or antique, there was always something new to see.

He was also proud of his German heritage. Wally shopped for ornaments from around the world but especially from Germany and Austria. Each year, Bronner's customers purchase more than two million ornaments, designed at Bronner's with Bible verses on the back and made in Europe, which made Wally one of the biggest buyers of ornaments in the world.

Going a step further, in 1992 Wally went to Oberndorf with a request: with Austria's permission, Bronner's planned to erect a replica of the Oberndorf (Salzburg), Austria, Silent Night Memorial Chapel in tribute to the Christmas hymn "Silent Night" and in thankfulness to God. It's considered a national treasure in Austria and draws people from around the world. Having worked with Wally for decades, the Austrian authorities knew the man and gave their permission readily, but with conditions: he could not hold church events like weddings in the chapel, he had to

replicate exactly the original architecture and materials of the chapel and he had to have clear and prominent references to the original chapel in Oberndorf. Wally agreed and had it built in Frankenmuth on his property. At the official unveiling of the chapel, the mayor of Oberndorf and other Austrian dignitaries were in attendance.

Wally Bronner passed away in 2008, and the business is now run by Wally's wife and family. People continue to visit in an endless stream, arriving every day of the year. Bronner's is about ninety minutes away from Detroit, north on I75.

CONCLUSION

Eventually, the special day winds down: Christmas tree lights are switched off, torn wrapping paper fills a plastic garbage bag, unwrapped toys are put back under the tree, the last dinner dishes are in the dishwasher that churns quietly, the television off, the fire in the fireplace dying: a tired moment to reflect.

Are we still good people? Are we as good as people were one hundred years ago? It's something people today talk about; being good can feel trivial when problems seem so huge and serious and final. So, I'm not sure. Perhaps we're the same people our distant relatives were. Perhaps were just as good, but maybe not. We're certainly not as religious as people were in the past. Church attendance is far below what it used to be. Some would point that out and say that it proves we're not as good as we used to be, but I'm not convinced that that's true.

Like people in the past, what I think we still need is for at least once a year to set down our everyday life and think differently. Just set things down. This is not like stopping at a bar after work for a drink. It's also not buying a plane ticket and escaping to a beach to relax in the sun, as nice as that is. This is being with people at work or neighbors or family or children in places we always are but thinking and feeling differently about them and about ourselves. It's not just about smiling, having fun and buying stuff for the kids and others. I think it's about seeing your colleagues happy, your boss wearing an ugly Christmas sweater or your children being kind to their younger sister, loving and thoughtful of other children. It's remembering,

without saying it, that these are virtues that we share. What do I truly value? It moves us from thinking that *this is what I value* to *this is what we value.* It's a reminder that when we choose to, we can be good.

Our job and those things we set down will be there after Christmas, waiting for us. We know that. This is reality after all.

Are we still good? Are we considerate, compassionate, do we still show kindness to strangers like they did in the past? I don't know. Maybe that's not the question. We are human and pausing for a moment, seeing and sharing what we think matters in life is an important need of humans now as in the past; maybe that is what links us to the past. Christmas is part of renewal, something that keeps us going, to repair the damage done to ourselves over a year, to continue this long life. I think it's essential.

THEN AS NOW, CHRISTMAS Day in 1865 drew to a close, as reported in the *Free Press* at the time:

> *Eyes are closed, loose things gathered and toys put aside. The roar of the hearth grate dies down, its eyes of flame grow dim, and one by one its red coals turn black. All are asleep, save perhaps, the mother, who like a guardian angel breathes a kiss on the foreheads of her darlings, with the fervent prayer that God, in His mercy, may spare them many another happy Christmas.*

BIBLIOGRAPHY

Austenberry, John. "The First Christmas on the River Raisin 200 Years Ago." *Monroe Evening News*, December 24, 1984.

Bagshaw, Marcus, "Origins of the Victorian Christmas card" 'Royal Pavilion & Museums, Brighton & Hove 2018. https://brightonmuseums.org.uk.

The Beacon Hill Collection: Inspired by the Early Designers & Craftsmen of the Eighteenth Century Who Created & Made Furniture of Lasting Beauty in Keeping with the Graceful Living of the Times. Detroit, MI: J.L. Hudson Company, 1940.

Bjorn, Lars, and Jim Gallert. *Before Motown: A History of Jazz in Detroit, 1920– 1960*. Ann Arbor: University of Michigan Press, 2001.

Brandow, Judi. *Celebrating the Tradition: The Victorian Christmas*. Golden, CO: U.S. Department of Agriculture, Forest Service, Rocky Mountain Region, 2001.

Bronner, Wallace John. *Sharing Joy 365: An Autobiography of Wally Bronner*. Frankenmuth, MI: Bronner's CHRISTmas Wonderland, 2006.

Burke, Thomas. *The History of the Ford Rotunda, 1934–1962: Dearborn's Pride of the Past*. Hicksville, NY: Exposition Press, 1977.

Burton, C. *The City of Detroit Michigan, 1701 to 1922*. Chicago: SJ Clarke Publishing, 1922.

Carson, David A. *Grit, Noise and Revolution: The Birth of Detroit Rock 'n' Roll*. Ann Arbor: University of Michigan Press, 2005.

Chase, Ernest Dudley. *The Romance of Greeting Cards, an Historical Account of the Origin, Evolution and Development of Christmas Cards, Valentines, and Other Forms of Greeting Cards*. Dedham, MA: Rust Craft, 1956.

"Christmas: Plastic Toys in Vogue." *Plastics*, November 2011.

Coffey, Dennis. *Guitars, Bars and Motown Superstars*. Ann Arbor: University of Michigan Press, 2009.

A Cookbook Containing 400 Choice Recipes as Practically Used by the Ladies of the West Grand Boulevard M.E. Church and Their Friends. Detroit, MI: Fourth Division of the Ladies Aid Society, 1923.

Corbett, Lucy. *French Cooking in Old Detroit Since 1701*. Detroit, MI: Wayne State University Press, 1951.

Crathern, Alice Tarbell. *In Detroit Courage Was the Fashion*. Detroit, MI: Wayne State University Press, 1953.

Cunningham Croly, Jane. *Jennie Junes American Cookery Book*. New York: American News Company, 1870.

DeKnight, Freda. *A Date with A Dish: A Cookbook of American Negro Recipes*. New York: Hermitage Press, 1948.

de Tocqueville, Alexis. *Memoir, Letters and Remains of Alexis de Tocqueville*. London: Macmillan, 1862.

Ellsworth, M.W., and Tinnie Ellsworth. *The Successful Housekeeper: A Manual of Universal Application, Especially Adapted to the Everyday Wants of American Housewives; Embracing Several Thousand Thoroughly Tested and Approved Recipes, Care and Culture of Children, Birds, and House Plants; Flower and Window Gardening, etc.; with Many Valuable Hints on Home Decoration*. Detroit, MI: M.W. Ellsworth, 1882.

Family Christmas Online. "Old Christmas Tree Lights(tm)." https://familychristmasonline.com.

Formanek-Brunell, Miriam. *Made to Play House: Dolls and the Commercialization of American Girlhood, 1830–1930*. Baltimore, MD: Johns Hopkins University Press, 1993.

Franklin, Aretha, and David Ritz. *Aretha, From These Roots*. New York: Random House, 1999

Gay, Cheri. *Lost Detroit*. London: Anova Books, 2013.

Gordy, Berry. *To Be Loved, the Music, the Magic, the Memories of Motown*. New York: Warner Books, 1994.

Hauser, Michael, and Marianne Weldon. *Hudson's: Detroit's Legendary Department Store*. Charleston, SC: Arcadia Publishing, 2004.

———. *Remembering Hudson's, The Grand Dame of Detroit Retailing*. Charleston, SC: Arcadia Publishing, 2010.

———. *20th Century Retailing in Downtown Detroit*. Charleston, SC: Arcadia Publishing, 2008.

Hess, Jonathan, and Karen Hess. *The Taste of America*. New York: Penguin Books, 1977.

Hoffman, David. *Kid's Stuff: Great Toys from Our Childhood*. San Francisco: Chronical Books, 1996.

Irving, Washington, "The Sketchbook of Geoffrey Crayon, gent. [pseud.]" New York: C.S. Van Winkle, 1819.

James, Lee Morton, and Lester E. Bell. *Marketing Christmas Trees in Michigan*. East Lansing, MI: Michigan State College, Department of Forestry, 1954.

Janvrin, Mary W. *Queen of the Household: A Carefully Classified and Alphabetically Arranged Repository of Useful Information on Subjects That Constantly Arise in the Daily Life of Every Housekeeper—A Guide to the Best and Easiest Ways of*

Accomplishing Home Work in Its Various Departments. Detroit, MI: Ellsworth and Brey, 1900.

Kujawski, Kim. "French Canadian Christmas, Holiday Traditions from the Era of New France and Beyond." French-Canadian Genealogist, 2019. https://www.tfcg.ca.

Mason, Emily. *Christmas in Detroit a Hundred Years Ago*. Detroit, MI: Detroit Public Library, 1942.

Meyer, Patricia, and Amy Catallo. *Remembering the Ford Rotunda*. Dearborn, MI: self-published, 2002.

Mintz, Steven. *Huck's Raft, a History of American Childhood*. Cambridge, MA: Belknap Press of Harvard University Press, 2004.

Moore, Clement C., "A Visit from St. Nicholas." With a facsimile of the autographed poem from the archives of the New York Historical Society, Alpine on the Hudson, New Jersey, 1930.

Nissenbaum, Stephen. *The Battle for Christmas*. New York: Vintage Books, 1996.

Paradise Valley Days. Detroit, MI: Detroit Black Writer's Guild, 1998.

Pitrone, Jean Maddern. *Hudson's Hub of America's Heartland*. West Bloomfield, MI: Altwerger and Mandel Publishing Company, 1991.

Posner, Gerald. *Motown, Music, Money, Sex and Power*. New York: Random House, 2002.

Restad, Penne L. *Christmas in America*. London: Oxford University Press, 1996.

Richter, Felix. "Who Puts the Lights on the Tree?" December 2, 2021. https://www.statista.com.

Ritz, David. *Respect: The Life of Aretha Franklin*. New York: Little Brown and Company, 2014.

A Russian Collection of Authentic Czarist Treasures from the Winter Palace, Tsarskoye Selo, and Other Royal Palaces: At the J.L. Hudson Co., Commencing April 11ᵗʰ. Detroit, MI: J.L. Hudsons Co., 1920.

Solomon, Linda. *The Queen Next Door: Aretha Franklin, An Intimate Portrait*. Detroit, MI: Wayne State University Press, 2019.

Songbook. "Motown's 1962 Motortown Revue." https://songbook1.wordpress.com.

Stark, George W. *Detroit, an Industrial Miracle*. Detroit, MI: Detroit Directory of Business and Industry, 1951.

Stocking, William, comp. *Detroit Statistical Records*. Detroit, MI: Detroit Board of Commerce, 1923.

The Story of Hudsons. Detroit, MI: J.L. Hudsons Co., 1962.

Tasker, Greg. *Sanders Confectionery*. Charleston, SC: Arcadia Publishing, 2006.

White, Gleeson. *Christmas Cards and their Chief Designers*. London: Offices of the Studio, Frederick A. Stokes, 1895.

Wilcox, Orlando. *Shoepac Recollections*. New York: Bunce and Brother, 1856.

Wilson, Sunnie, and John Cohassey. *Toast of the Town: The Life and Times of Sunnie Wilson*. Detroit, MI: Wayne State University Press, 1998.

Wisbey, Herbert. *Soldiers Without Swords: A History of the Salvation Army in the United States*. New York: Macmillan, 1955.

ABOUT THE AUTHOR

Motor City native Bill Loomis is the author of *Detroit's Delectable Past*, *Detroit Food*, *On This Day in Detroit History* and *Secret Societies in Detroit*, as well as numerous articles for the *Detroit News*, *Michigan History Magazine*, *Hour Detroit*, *Crains Business Detroit* and a variety of national media, such as the *New York Times*. He has been interviewed on the PBS radio show *Splendid Table* and was a regular contributor to *Stateside with Cynthia Canty* on PBS-WUOM in Ann Arbor. He also appears regularly on Detroit talk shows and history-based shows like Mysteries at the Museum. He lives in Ann Arbor with his wife and four children.